AMERICA

THIS GREAT LAND

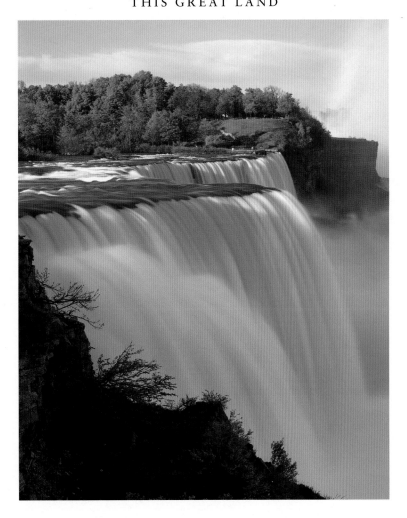

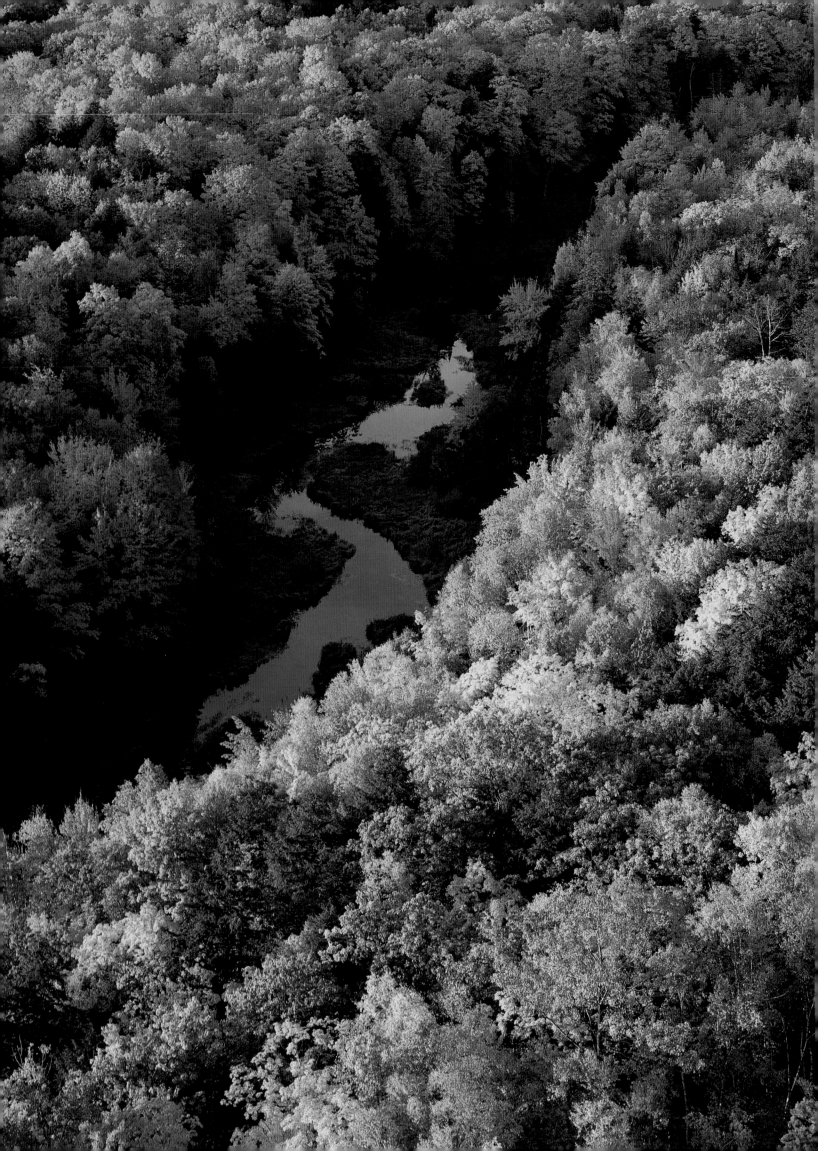

AMERICA
THIS GREAT LAND

Photography by Fred Hirschmann

Essays by Suzan Hall

GRAPHIC ARTS CENTER PUBLISHING®

International Standard Book Number 1-55868-363-1

Library of Congress Catalog Number 97-73082

All photographs © MCMXCVII by Fred Hirschmann,

except page 96, which is © MCMXCVII by John Marshall

Text and compilation of photographs © MCMXCVII by

Graphic Arts Center Publishing Company

P.O. Box 10306 • Portland, Oregon 97296-0306 • 503/226-2402

President • Charles M. Hopkins

Editor-in-Chief • Douglas A. Pfeiffer

Managing Editor • Jean Andrews

Photo Editor • Diana S. Eilers

Cover Design • Robert Reynolds

Production Manager • Richard L. Owsiany

Book Manufacturing • Lincoln & Allen Company

Printed in the United States of America

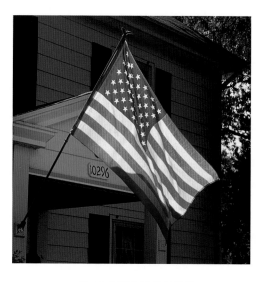

CONTENTS

◄ ◄ Niagara Falls embodies both the 167-foot American Falls, which are shown here, and the 158-foot Canadian Horseshoe Falls.
◄ Michigan's Porcupine Mountain Wilderness State Park exemplifies autumn colors found mostly in areas east of the Mississippi River.
▲ Congress adopted the American flag's design on June 14, 1777, a year after George Washington asked Betsy Ross to make the flag.
► Point of the Arches in Olympic National Park, Washington, lies in the extreme northwest corner of the continental United States.

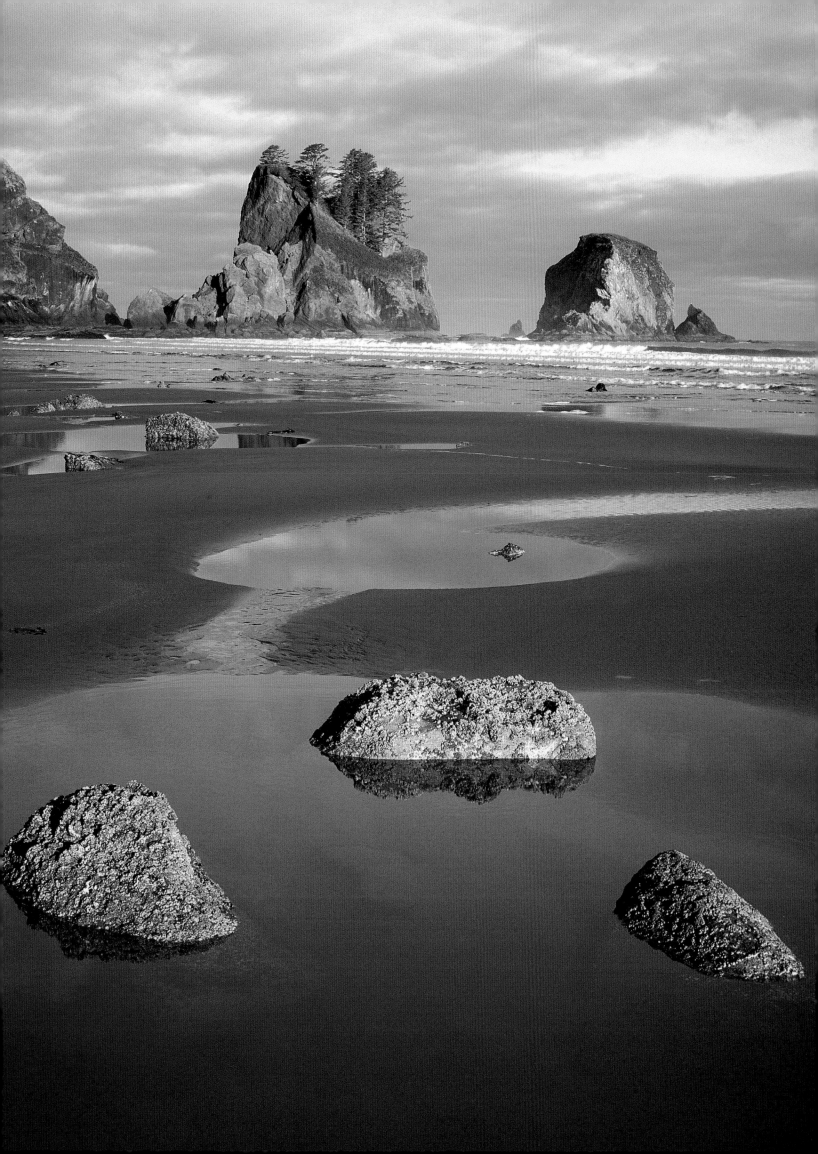

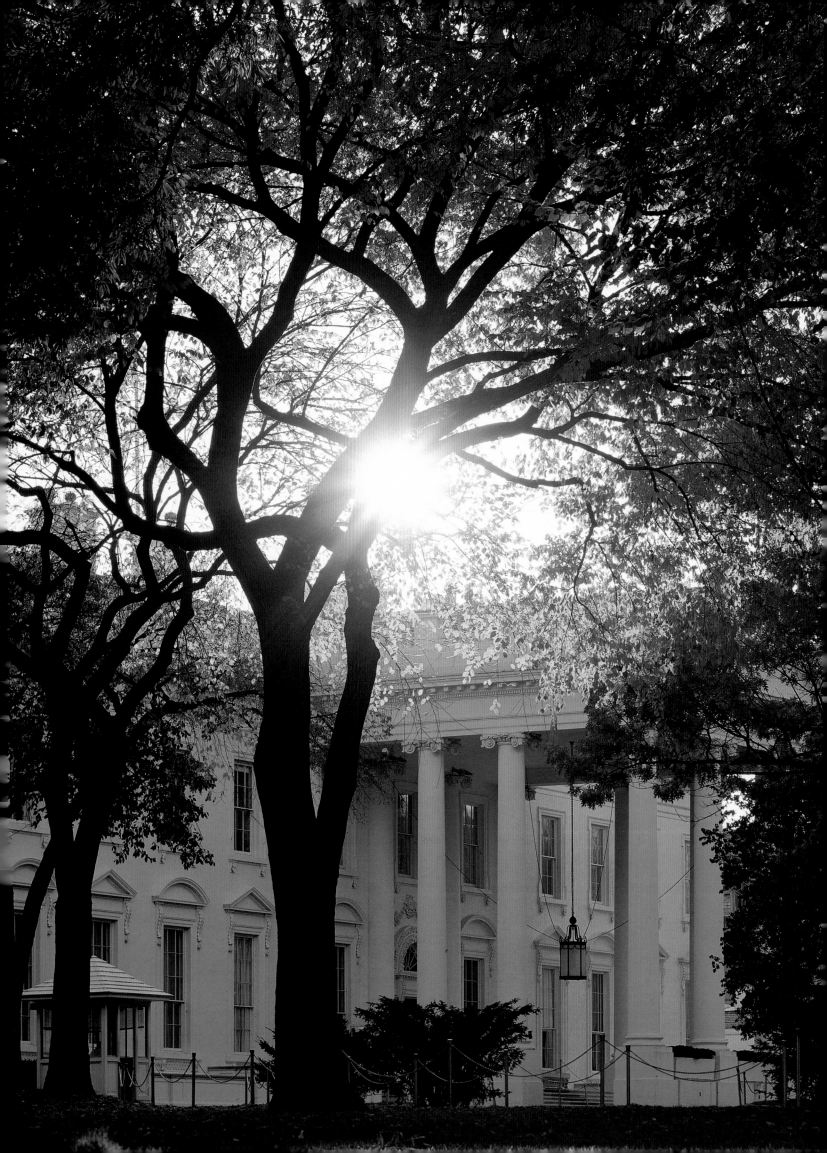

MIDDLE ATLANTIC

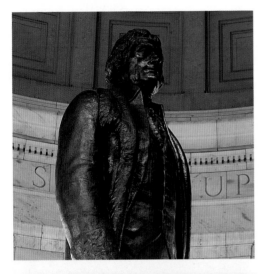

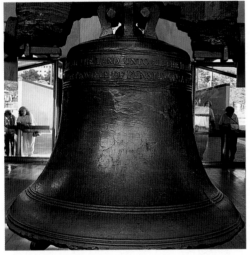

◄ *Built in 1792, the White House has been home to presidents since 1800, when it was occupied first by John Adams. The British burned it in 1814, but it was rebuilt later.*
▲▲ *The Thomas Jefferson Memorial was created to honor America's third president.*
▲ *The Liberty Bell was cast in the mid-1700s to celebrate the fiftieth anniversary of the Commonwealth of Pennsylvania.*

This is where the United States of America was born. It was conceived in Philadelphia, in June 1776, when the Second Continental Congress voted to formalize a rebellion already underway and Thomas Jefferson expressed the new nation's credo in the Declaration of Independence.

Then, in six years of war, America's bedraggled, ill equipped, determined rebels wore out the British and won their freedom. The marks of their struggle are scattered through the Mid-Atlantic states; there is no keener distillation of misery and grit than the story of Washington's winter at Valley Forge.

But it was in the sweltering Philadelphia summer of 1787 that American government was truly born. With debate as heated as the weather, fifty-two impassioned delegates to the Federal Convention argued their way to the most successful constitution in history. Most venerable among them were George Washington and Benjamin Franklin. Visionary as they were, those founding fathers would be amazed by today's realities. Designed for four million people in thirteen colonies along the Atlantic Coast, the Constitution now serves more than two hundred fifty million people in fifty states in a nation that spans the continent and reaches into the Pacific and up to the Arctic.

Washington, D.C., the capital that had not yet been planned, is now a mature city, as grand as any of its older European counterparts, and a potent force in the world affairs. New York has become one of the largest cities in the world, an international arbiter of culture and finance.

It has happened quickly. When Thomas Jefferson became America's third president approximately two centuries ago, the White House was one of a scattering of new buildings in a backwoods clearing. The problems of Congress included mosquitoes and red clay mud. The president planted his own lawn, and when Meriwether Lewis brought back bears from his Western expedition, they were kept in Jefferson's fenced backyard.

New York City, while older than the capital, is still a child compared to London or Paris. It is true, the Dutch paid less for Manhattan Island in 1626 than it costs to have a good dinner there today. The transaction was meaningless, though, because Native Americans did not believe that land could be owned. Since then, a million and a half people have wedged themselves onto that 22.6-square-mile island, in a condensation of energy and diversity unlike any other in the world.

The Atlantic seaboard is weighted with population and power. Nearly one-tenth of the nation's population now lives in the crowded corridor between Washington, D.C., and New York City in a nonstop flow of communities that inspired the term *megalopolis*. But to focus on the urban is to miss the richness of the area. On the map, Manhattan is just a dot in a state that stretches to the shores of two Great Lakes. Playing counterpoint to the City's concrete intensity are the grand vistas of the Hudson River Valley; the verdant Appalachian Mountains; and the cool, clear Adirondack lakes. Pennsylvania, the broad state William Penn founded to nurture religious diversity, reaches westward with rich, rolling farmland, over the Alleghenies and past Pittsburgh, the city steel built.

Beyond the urban hustle, history lingers, tradition persists, and the work of the land continues. While Washington lawmakers debate and Wall Street deal makers negotiate, oyster men haul in bounty from the Chesapeake Bay, New Jersey farmers harvest produce, and Pennsylvania's Amish still work their fields with horse-drawn plows.

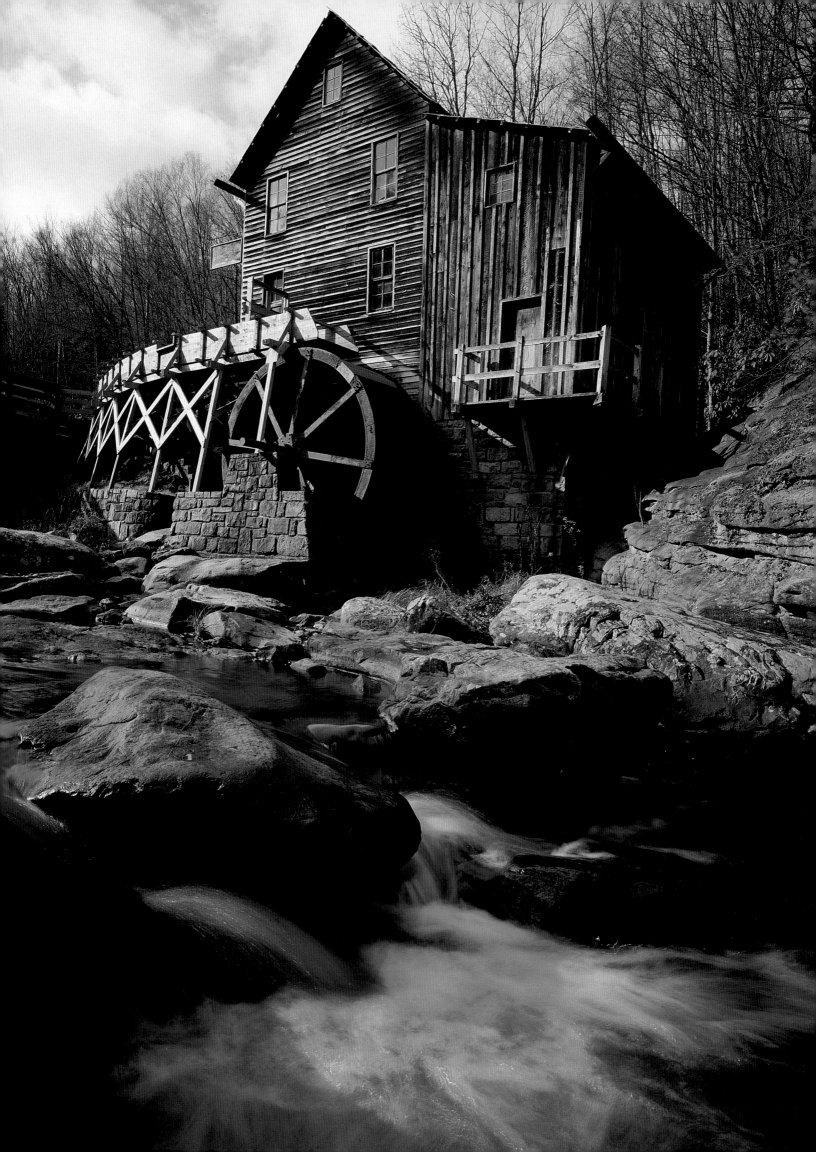

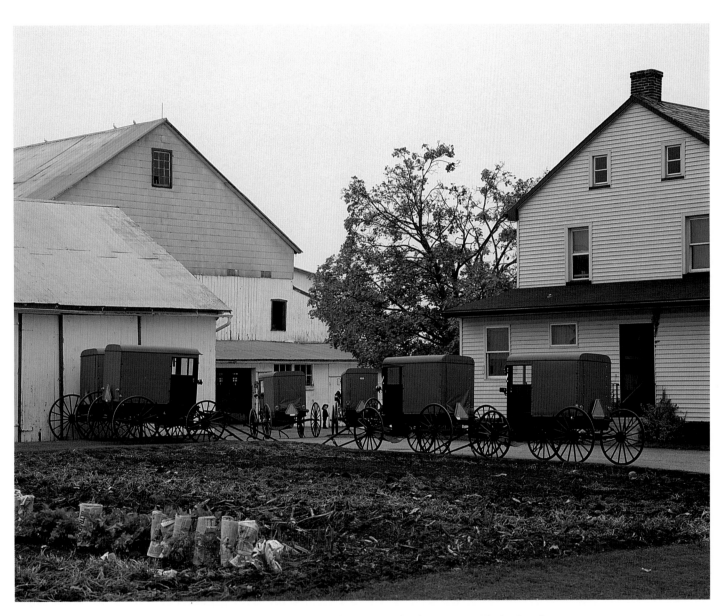

◀ In West Virginia's Babcock State Park, the "new" Glade Creek Grist Mill, completed in 1976, is a re-creation of Cooper's Mill. The basic structure came from the Stoney Creek Grist Mill, dating to 1890, and is a monument to the mills that once thrived in the state.
▲ Part of the Pennsylvania Dutch, the Amish broke away from the Swiss Mennonites in 1690, arriving in America about 1727.

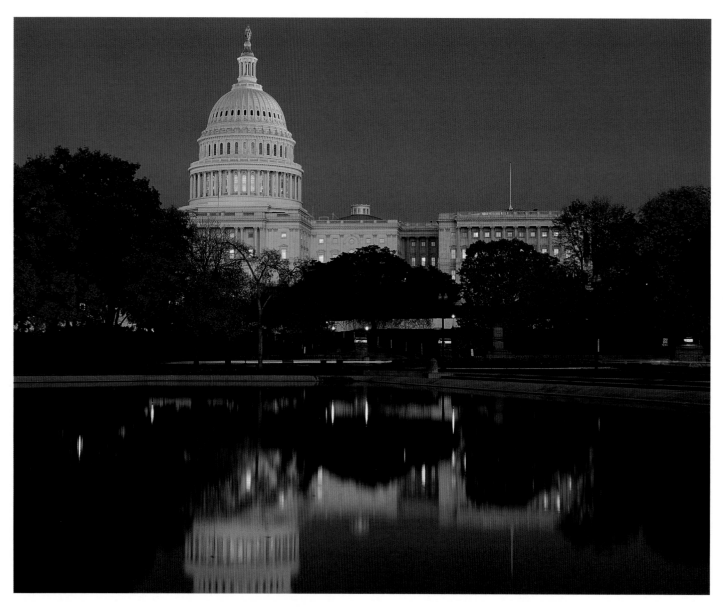

▲ Designed by William Thornton, the Capitol Building is where Congress meets. In 1793, George Washington laid the cornerstone.
► The 22.6-square-mile island of Manhattan, purchased in 1626 from the Man-a-hat-a Indians for twenty-four dollars, today supports a population of more than one and one-half million.
► ► In 1863, the Battle of Gettysburg left over fifty-one thousand casualties, more than any other battle ever fought in North America.

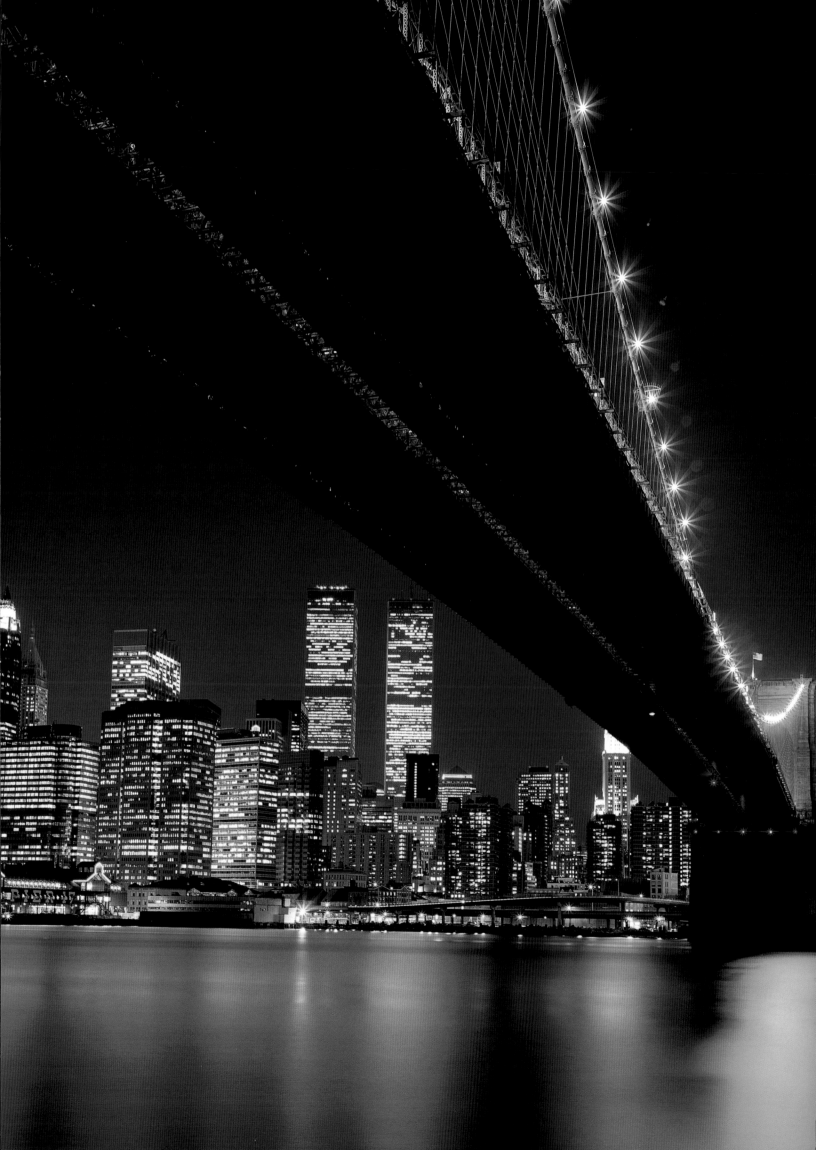

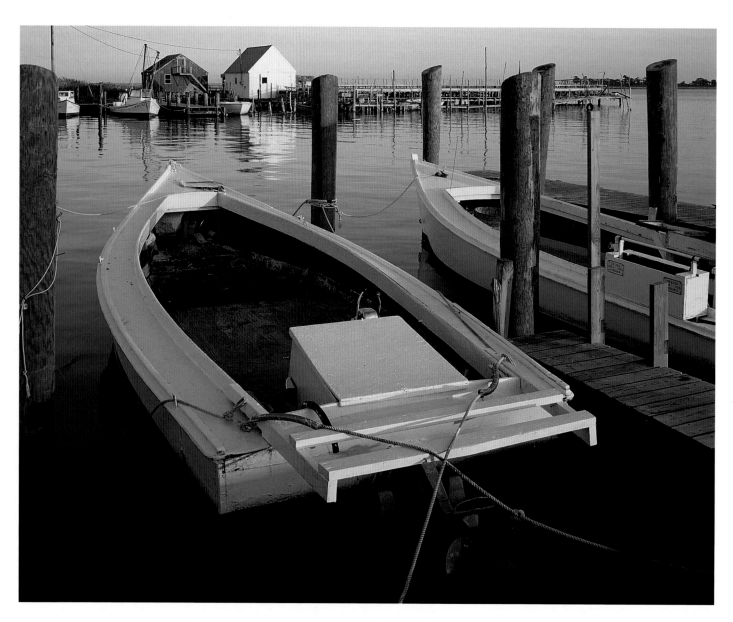

▲ One of many boats that account for the area's shellfish harvests rests at Saxis, Virginia, on Chesapeake Bay. The bay was the site of the first permanent English settlement in 1607—Jamestown.
▶ The U.S. Naval Academy chapel houses the crypt where John Paul Jones was buried. Established in 1845 at Fort Stevens in Annapolis, the academy has granted degrees to approximately sixty-one thousand cadets—including women, who were first admitted in 1976.

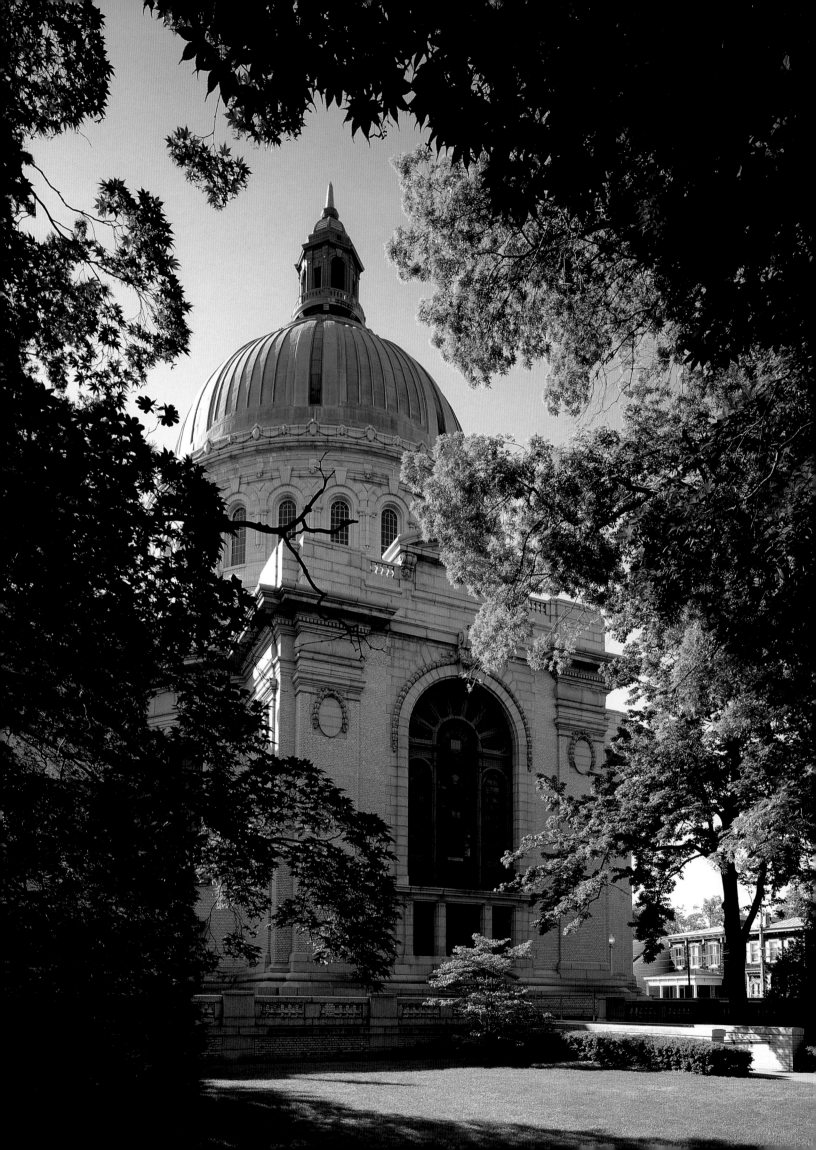

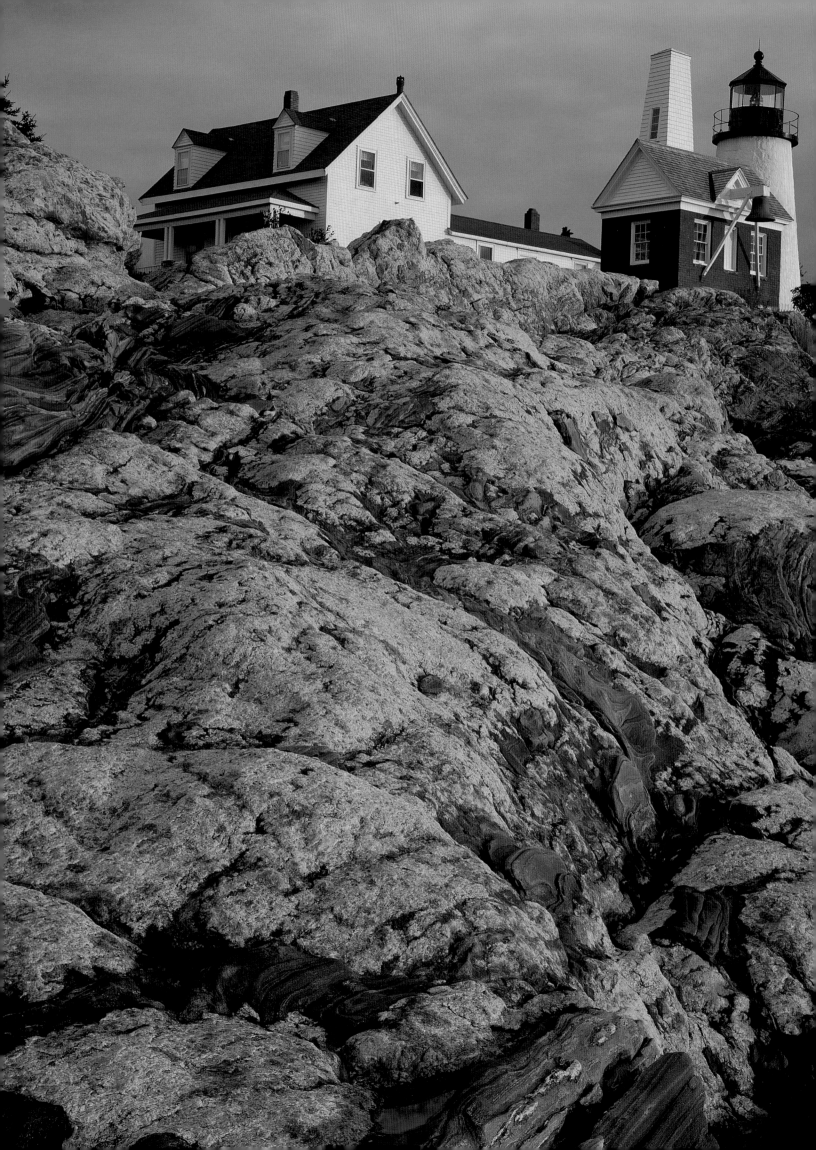

NEW
ENGLAND

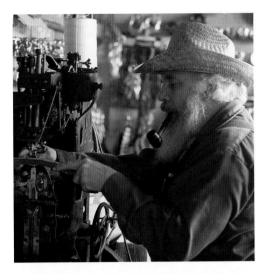

◄ *Pemaquid Point Lighthouse has stood watch on the shores of Maine since 1827.* ▲ ▲ *Vermont harbors numerous crafts-people who are highly skilled. A leather worker preserves the traditions that make up the fabric of New England's history.* ▲ *Great Stone Face, the Old Man of the Mountain, is an icon of New Hampshire.*

A covered bridge, a stone fence, a white-steepled church among the crimson trees, a bucket and tap on a sugar maple, a lobsterman in heavy weather gear hauling in his catch—everyone knows these images, and knows where they belong. This is the only region in America whose name references history, not locale. More than two hundred years after the Revolutionary War, this is New England, still.

This is where a small band of Pilgrims shivered and starved through the Massachusetts winter of 1621 and, the following autumn, celebrated the first Thanksgiving. This is where a handful of stubborn farmers fired the first shots of the Revolution, determined to hold the bridge at Lexington. This is where many of the values we hold most dear were first nurtured.

Those first colonists, who risked their lives for religious freedom, also brought with them strong convictions about government and education. New Englanders remain fiercely protective of individual rights and committed to participatory government. Town meetings are still held regularly in rural New England; to attend is to see elemental democracy at work. The Massachusetts Bay Colony committed early to public education, mandating grammar schools in 1642.

The first college on American soil was chartered in Boston in 1650. Oliver Wendell Holmes may have exaggerated just a bit when he described mid-nineteenth-century Boston as "The thinking center of the Continent, and therefore the Planet," but that city had, and still retains, a distinct academic flavor.

This is a venerable part of our nation, but in the longer view of history, our tenure here has been barely a moment. This land area is one of the oldest on earth. Distant ancestors of the Berkshires and the Green Mountains heaved up from the ocean depth approximately half a billion years ago. During the Ice Age, glaciers scoured the land, creating fertile plains, carving the ponds and rivers, dumping piles of rock and debris, and bestowing upon the land its present face. Then the climate began to warm, and the forests grew.

When the Pilgrims arrived, New England was almost entirely wooded. The rivers and good shallow beaches teemed with fish, and farmland was to be had for the clearing. From the Natives, who were better farmers than warriors, the settlers learned how to take advantage of the bounty. The hook of land they first settled was aptly named Cape Cod, and that practical fish became an unofficial regional symbol.

Geographically, this area is anything but homogeneous. New England breaks into at least three regions: the shore, where the early settlers clustered around the natural harbors and fishermen found wealth; the central valleys, where hardy farmers thrived and the industrial revolution began; and the timber-and-lakes country to the north and west, which is so untouched that, even now, it lures pilgrims from cities seeking freedom from stress.

The early explorers reported that sweet aromas met their ships as they approached the shores of New England—the fragrances of trees, wild strawberries, and burning cedar. Although the virgin forests no longer reach down to the shore, the New England woodlands still retain a strong allure. In autumn, their flamboyant colors draw "leaf peepers" by the carload.

The wild strawberries are fewer now, but New England still offers sensual pleasures, including wild Maine blueberries, tangy Vermont cheddar, fresh-pressed apple cider, and incomparable steamed lobster.

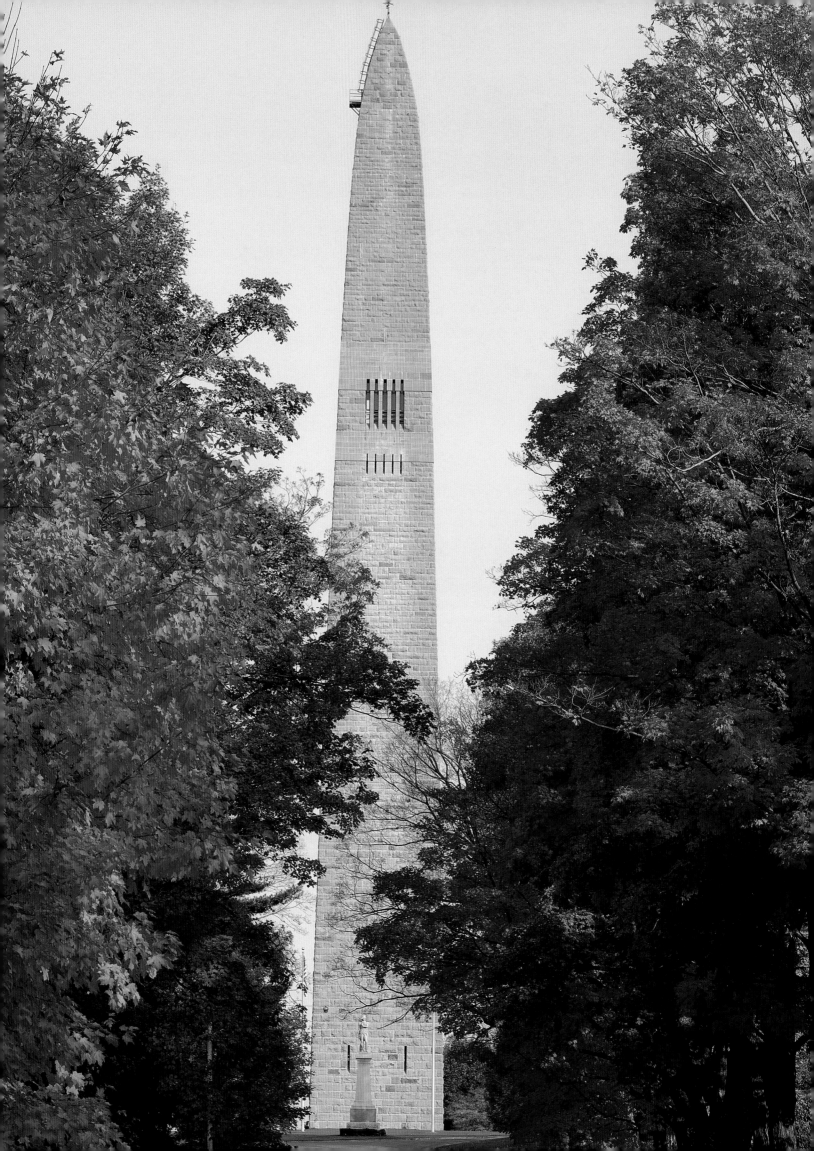

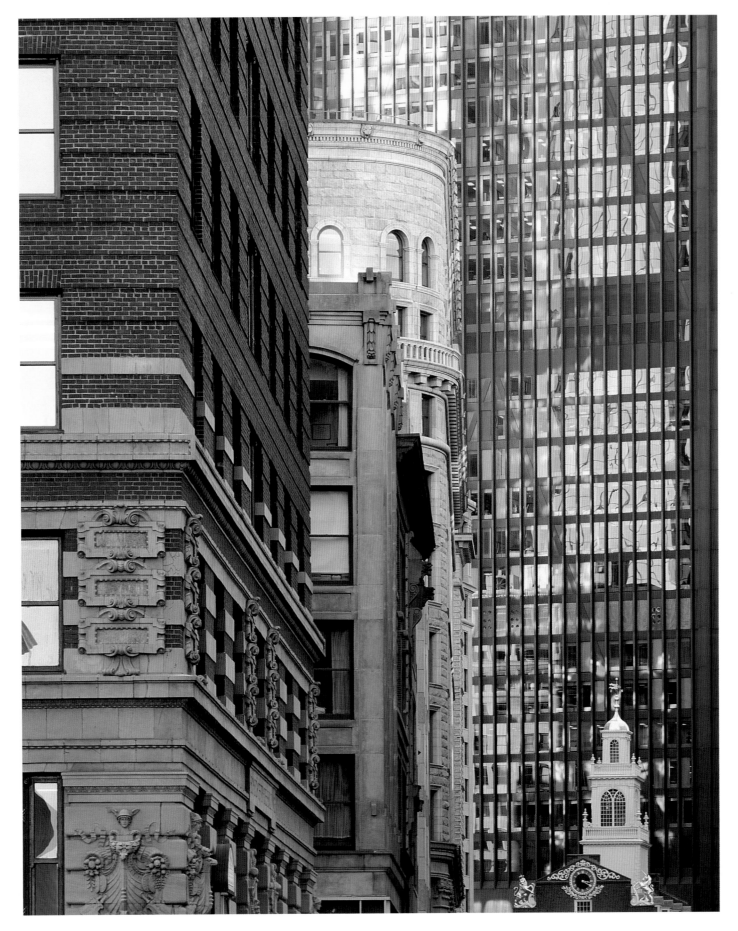

◄ The 306-foot Bennington Monument commemorates the August 16, 1777, Revolutionary Battle of Bennington.
▲ Dwarfed by the huge skyscrapers of modern Boston, the quaint Old State House, built in 1713, reflects colonial days.
▶ ▶ Vermont's Enosburg Falls typifies small-town America. Nearly 25 percent of the nation's population lives in small towns.

19

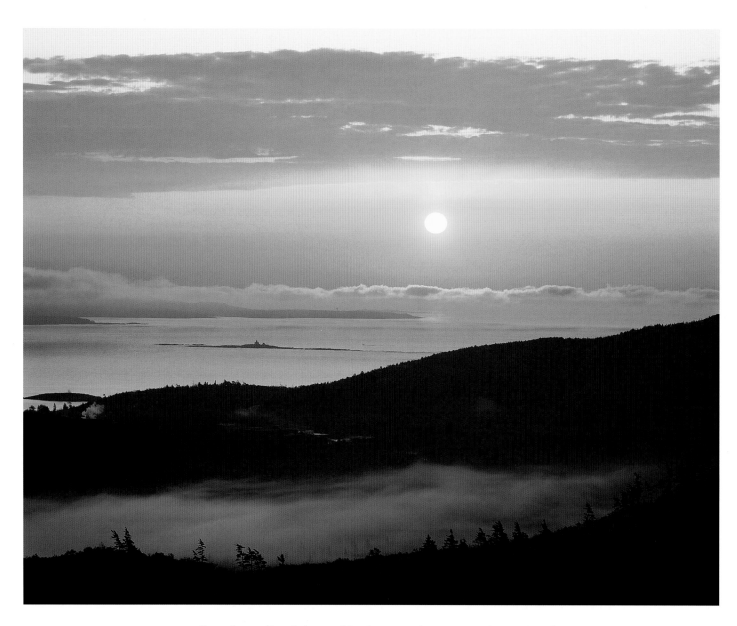

▲ Frenchman Bay is located in the second most popular national park, Maine's Acadia National Park. Established in 1919, the park, neither carved out of public lands nor bought with public funds, was envisioned and donated through efforts of private citizens.
▶ The whaler *Charles W. Morgan*, launched in 1841, is preserved at Connecticut's Mystic Seaport, a living history maritime museum.

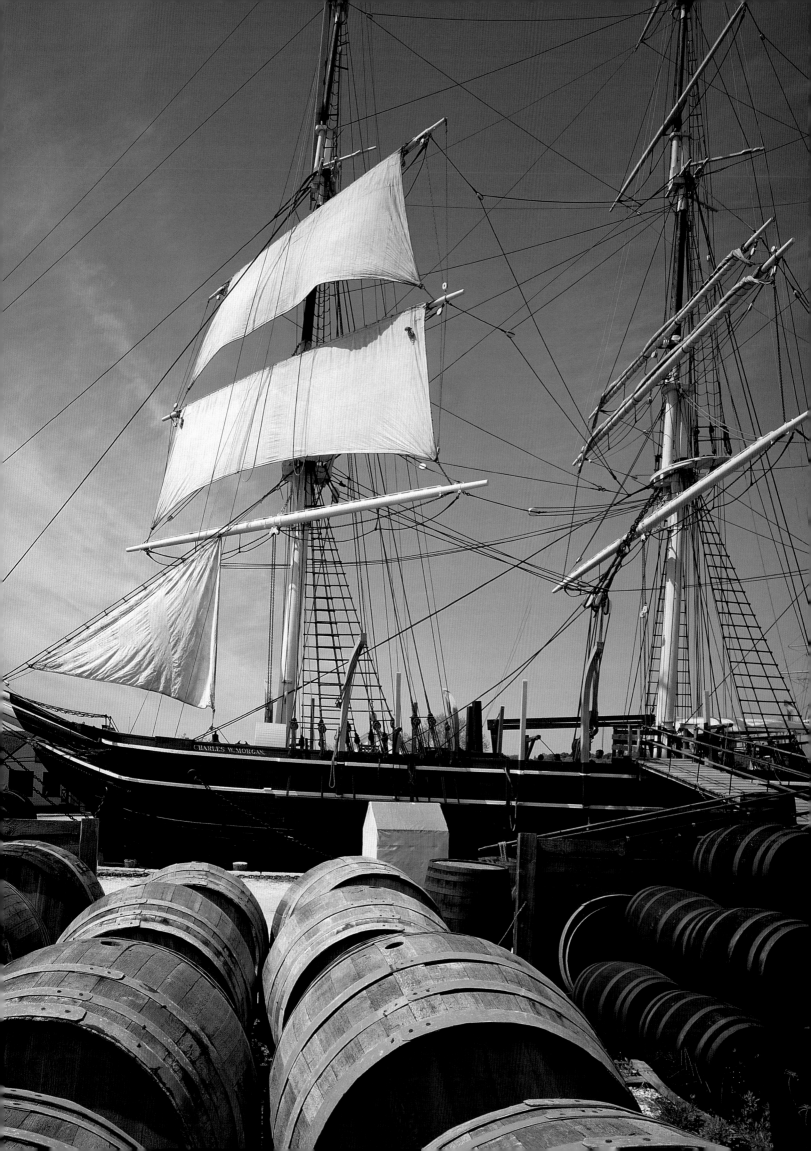

THE SOUTH

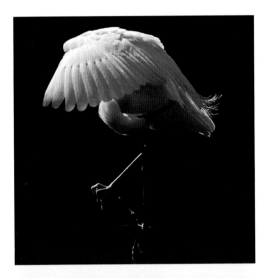

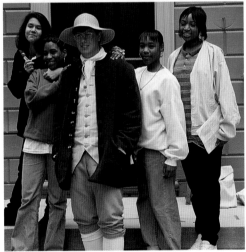

◄ *Ocracoke Harbor provides refuge in North Carolina's Outer Banks, islands that protect the mainland from the ocean's wrath.*
▲ ▲ *A snowy egret preens in Everglades National Park. A wetland of global importance, the Everglades are a World Heritage Site and International Biosphere Reserve.*
▲ *Thousands of children, as well as adults, enjoy experiencing Colonial Williamsburg, Virginia, where history is brought to life.*

Heritage, tradition, and a strong sense of place are woven into the fabric of Southern life. Outsiders, charmed by the overview, often miss the subtleties. That Southern accent is a case in point. To people from other parts of the country, all Southern accents sound similar. But Southerners will point out, with a certain pride, that there are many variations. Accents differ not just by state, but right down to home county.

History is woven into the fabric, too, and it is long and colorful. There is evidence of human settlements in the South as early as 1700 B.C. One of America's most important archeological sites is a Stonehenge-like mound construction in Louisiana.

The French and Spanish established outposts along the Gulf of Mexico a century before Pilgrims arrived at Plymouth Rock. They cared less about settlement than about quick riches and defending the fleets taking America's booty back to Europe. Both countries relinquished territorial claims, but left a rich legacy in the region's architecture, language, and food. No city in America is as European, or as unique, as New Orleans, with its French Quarter, jazz, spicy food, and Mardi Gras. The city's original attraction was its strategic location at the mouth of the Mississippi. Trappers, traders, miners, and farmers depended on that natural highway to move their products to markets at home or abroad.

North along the river, a few sadly splendid plantation houses still bear testimony to King Cotton's reign through the first half of the nineteenth century. Rising above bitter circumstances, the Africans imported as slaves to work those plantations have added another rich component to American culture. African-American food and music have become Southern staples, and slaves' descendants are making powerful contributions in every aspect of American life.

The landscape reinforces the dramatic character of the Deep South. Spongy bogs and bayous mark the area along the Gulf. Old mossy trees overhang waters that are home to delicacies called crayfish, as well as many other less savory creatures. In Georgia's Okefenokee Swamp, cottonmouth moccasins twine the tree roots, and fifteen-foot alligators ply the black waters.

Florida's Everglades Wilderness is a swamp of a different sort. Primarily a marshy grassland, it is punctuated by small islands of hardwood trees. Sawgrass, with leaves like teeth, grows as tall as twelve feet. Alligators, Florida panthers, and three hundred types of birds thrive in the Everglades.

North and east of the Gulf, the climate is more moderate, the landscape less dramatic, and the heritage less eclectic. While the French and Spanish jostled for position along the Gulf, the British put down roots along the Atlantic. Virginia, home of educated gentleman planters like Washington and Jefferson, was a bulwark of the original thirteen colonies. From there, the settlers flowed west through the Cumberland Gap into Kentucky and Tennessee, where the rolling green country is now dotted with white-fenced fields full of thoroughbred horses. North and South Carolina were also among the original thirteen colonies, and the gracious city of Charleston, built on rice and indigo fortunes, was a leading cultural center in Colonial America.

An outsider's South may be only clips from *Gone With the Wind*—white-columned plantation houses, uniformed gentlemen, ladies in flowing skirts and cartwheel hats. Still, these fondly-held stereotypes capture a broader truth. History has given the South an aura of glamour and drama that is as seductive as a whiff of wisteria on a warm Southern night.

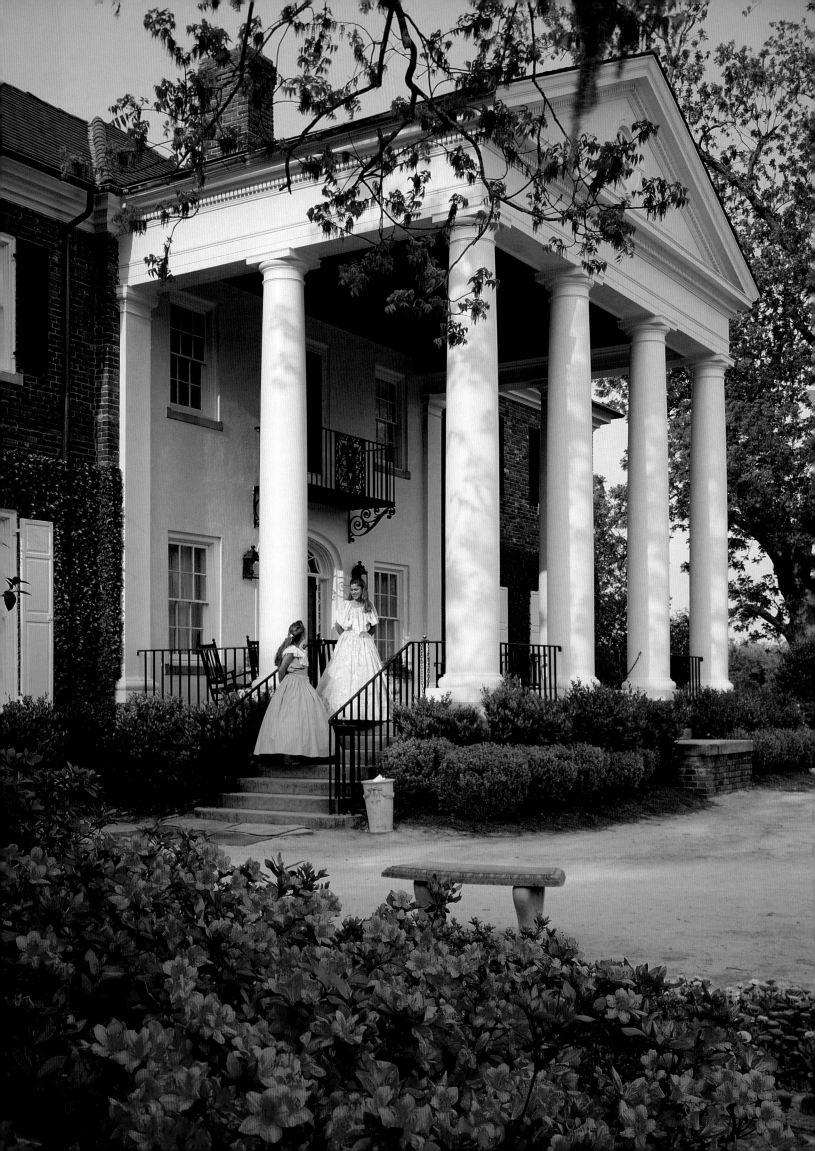

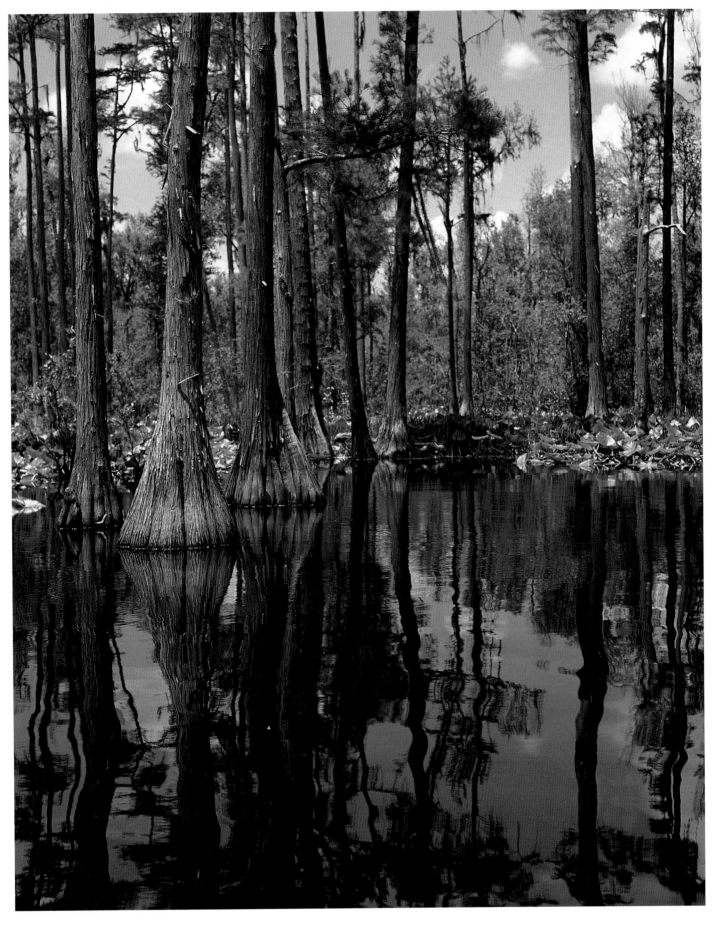

◄ Boone Hall, a South Carolina plantation, was a major producer of indigo and cotton in the 1700s and 1800s.
▲ Bald cypress and water lilies line Georgia's Suwanee River, in the Okefenokee National Wildlife Refuge.

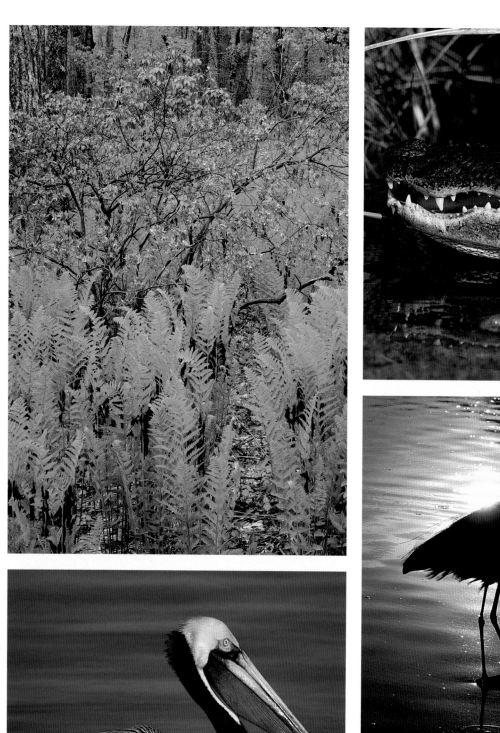

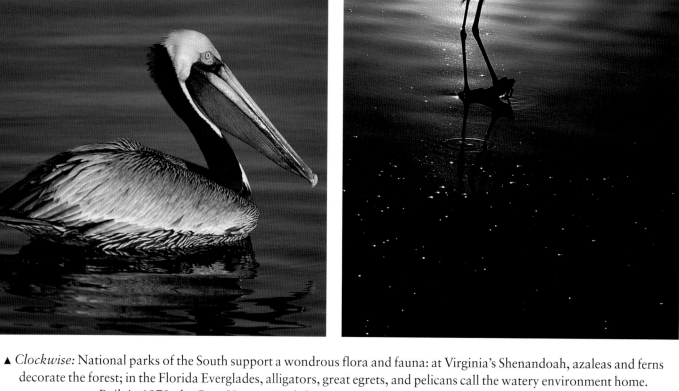

▲ *Clockwise:* National parks of the South support a wondrous flora and fauna: at Virginia's Shenandoah, azaleas and ferns decorate the forest; in the Florida Everglades, alligators, great egrets, and pelicans call the watery environment home.
▶ Built in 1870, the Cape Hatteras Lighthouse, at 208 feet, is the tallest in the United States.

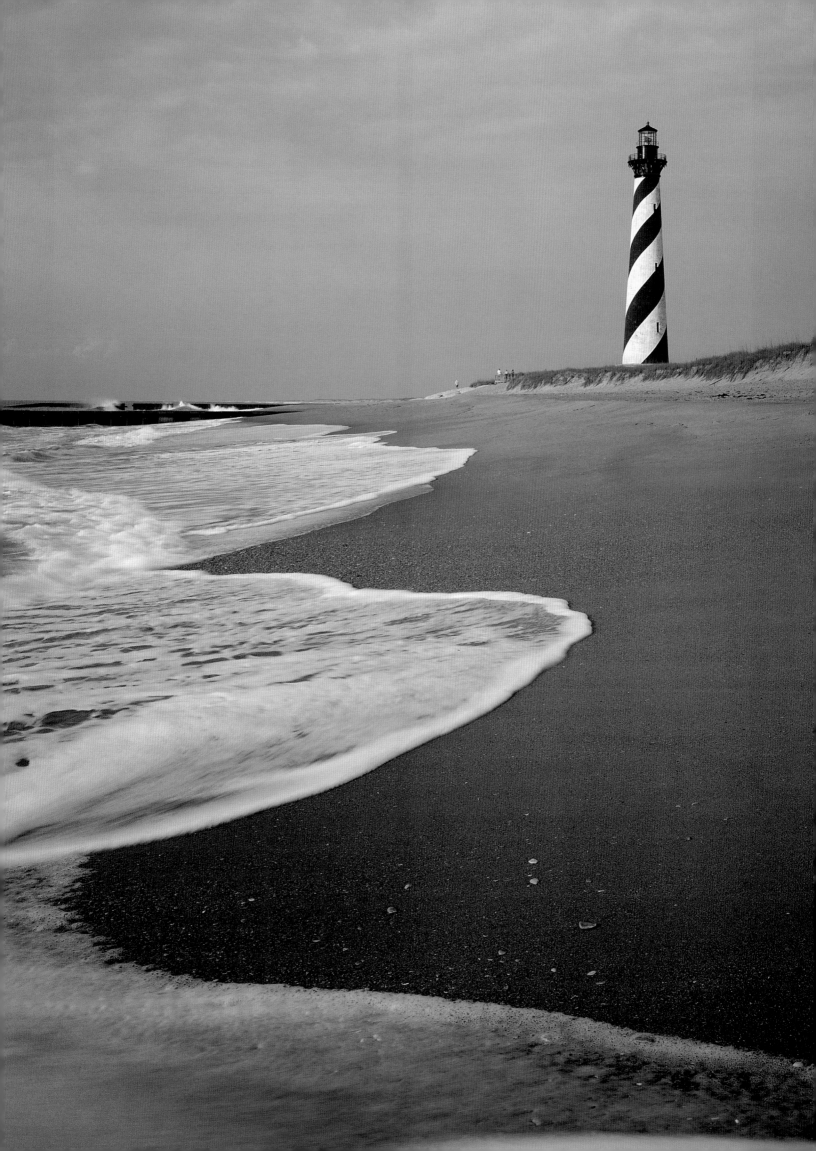

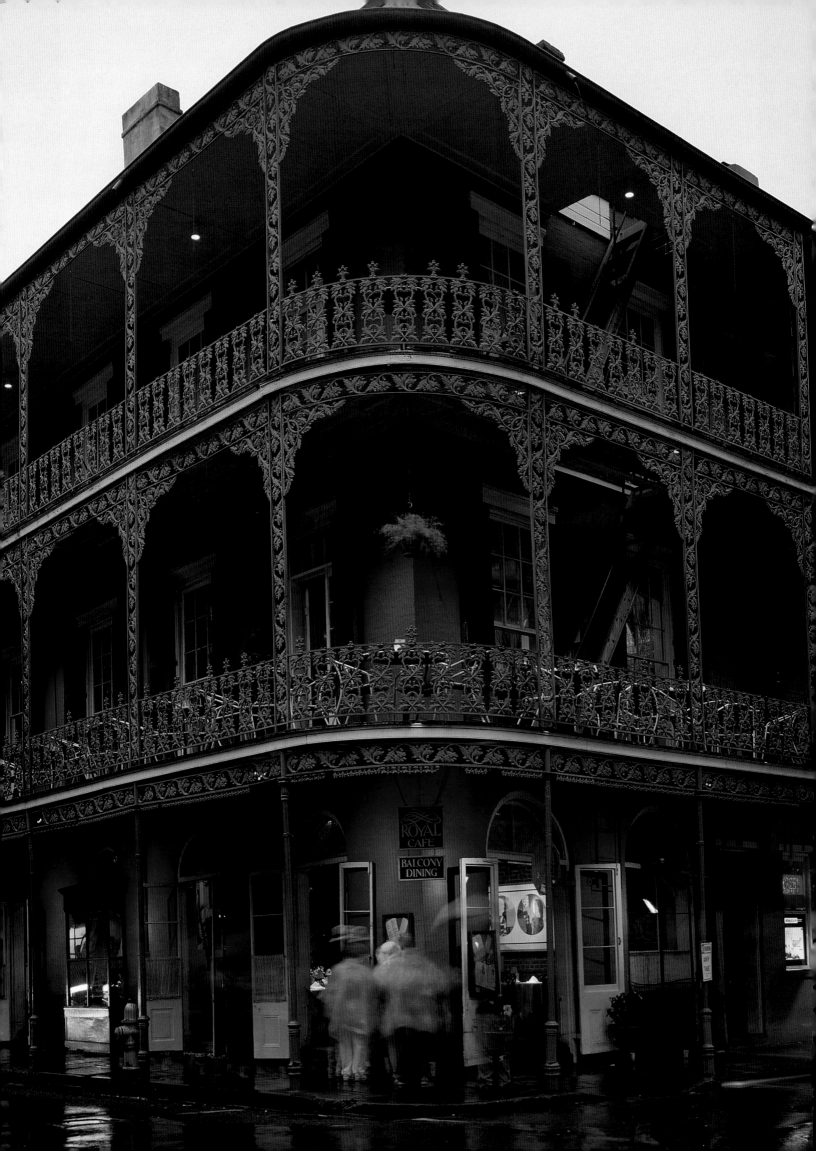

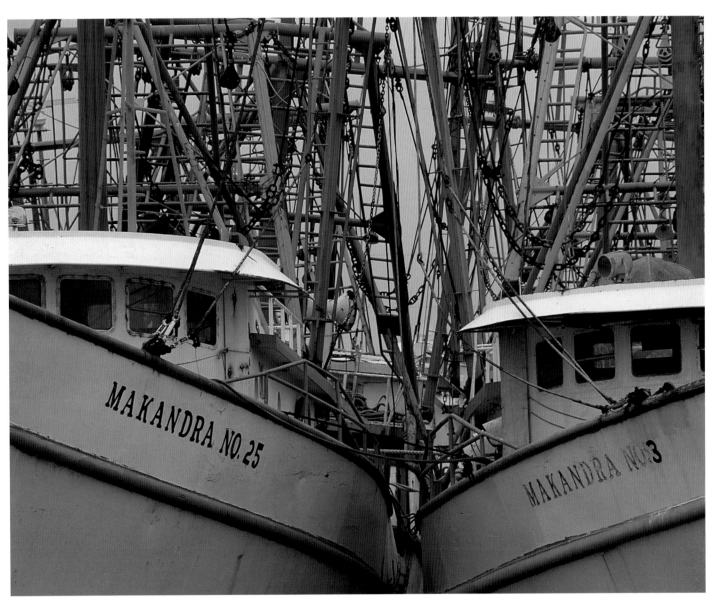

◄ The Royal Cafe is an example of early French architecture. New Orleans, between Lake Pontchartrain and the Mississippi River, was a French colony in 1718, a Spanish colony in 1762, and became part of the United States in the Louisiana Purchase of 1803.
▲ The Makandra fleet is docked at Alabama's Bayou La Batre. The westernmost extension of the Atlantic Ocean, the Gulf of Mexico supports shrimp, oysters, crab, mullet, and menhaden.

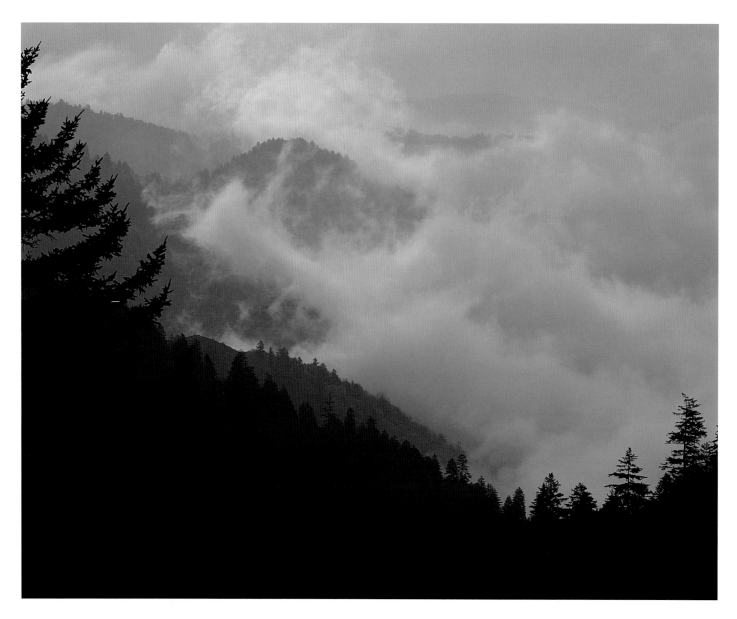

▲ Fog rises from Deep Creek in Great Smoky Mountains National Park, established in 1934. Fertile soils and abundant rain encourage some fifteen hundred kinds of flowering plants. The name "Smoky" comes from the smokelike haze that envelopes the mountains.
▶ The Tipton Place was built by "Hamp" Tipton in Cades Cove in the Smoky Mountains a few years after the end of the Civil War.

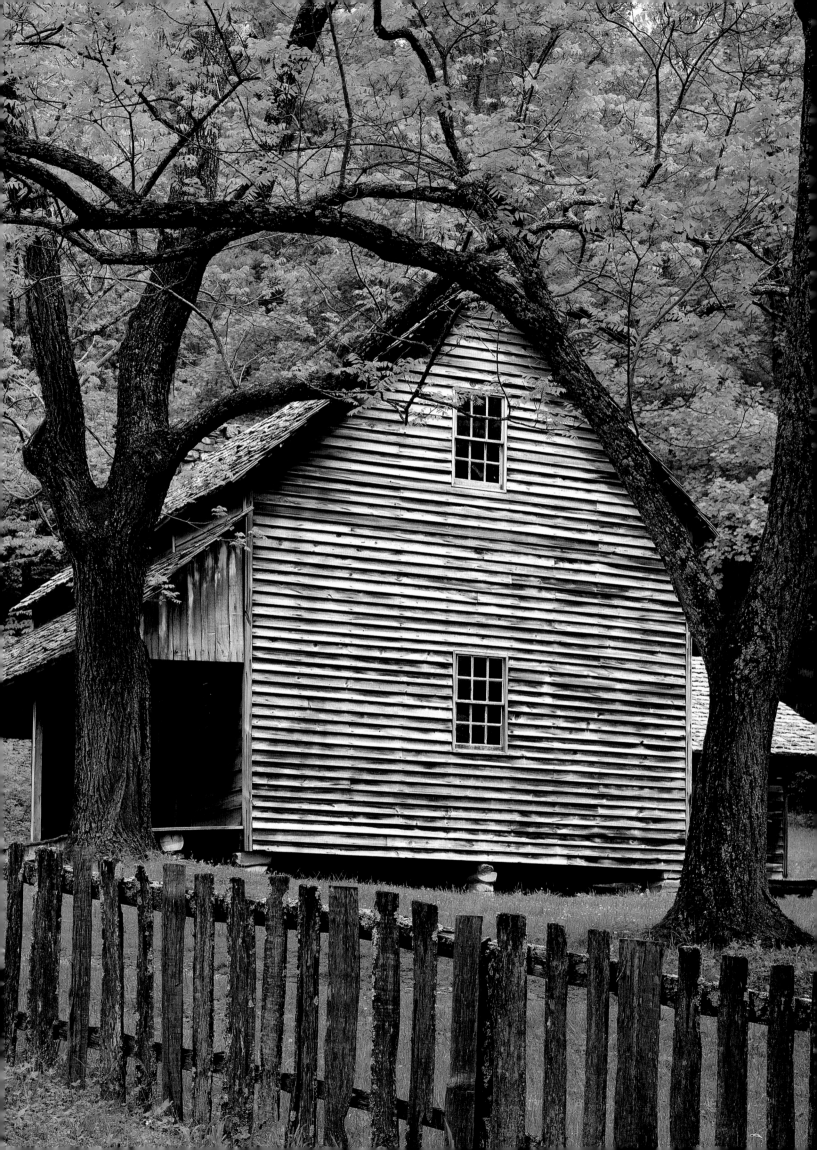

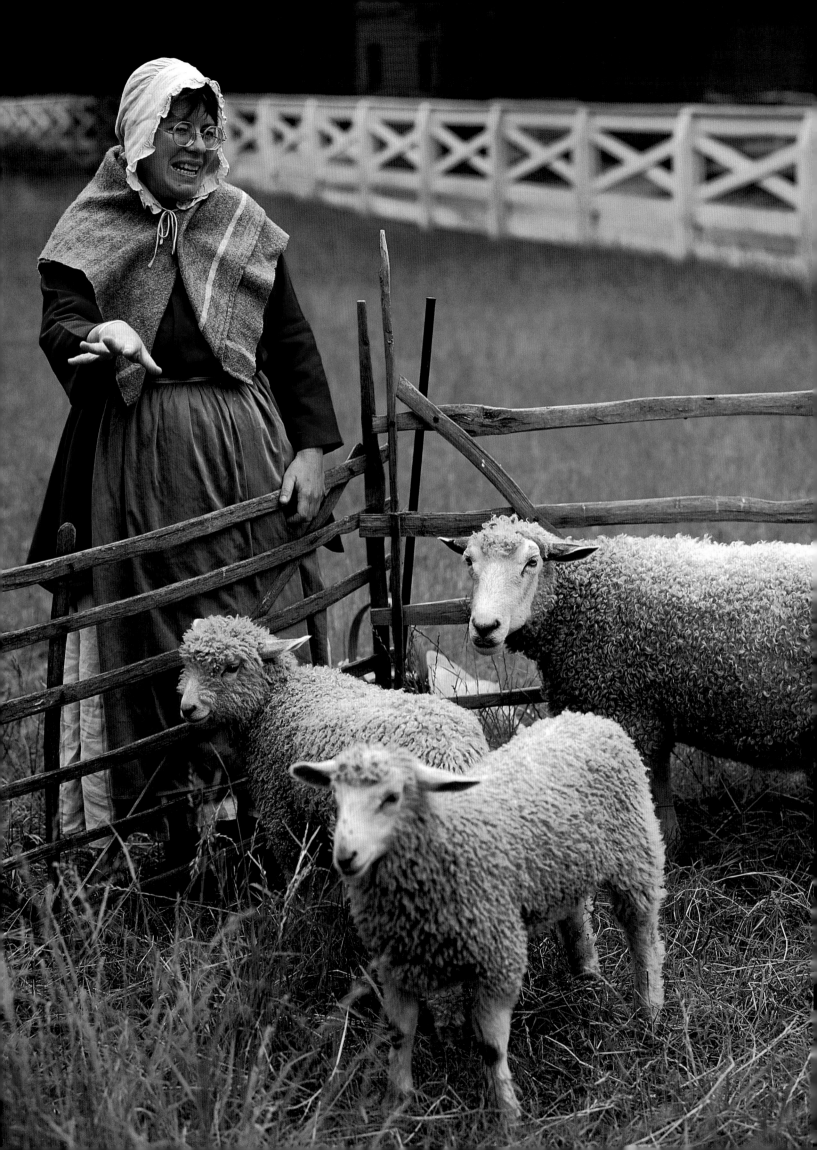

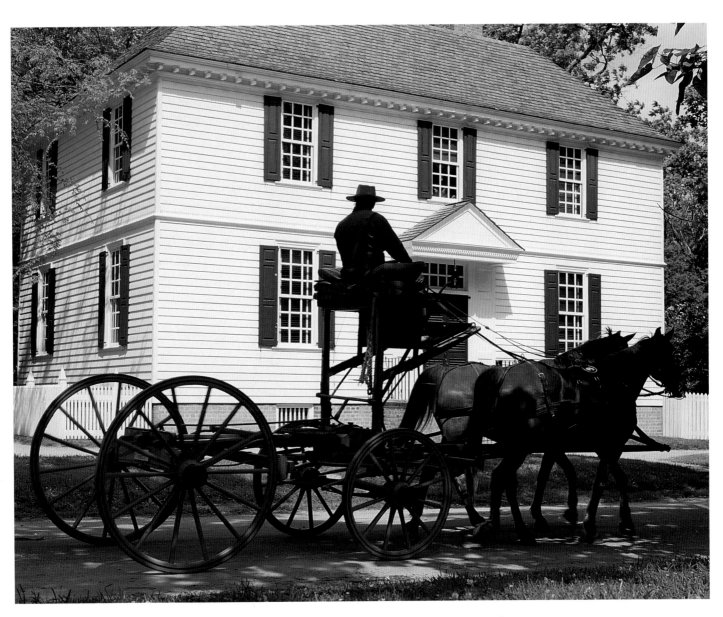

◄ Visitors to Colonial Williamsburg learn about Virginia's heritage. Leicester long-wool sheep are the subject of a living history discussion.
▲ Once Virginia's capital, Williamsburg was an important site during the American movement for independence. After the capital moved to Richmond in 1779, Williamsburg declined, but in 1926, with the help of John D. Rockefeller Jr. and W. A. R. Goodwin, work was begun to return it to its original late-1700s appearance.

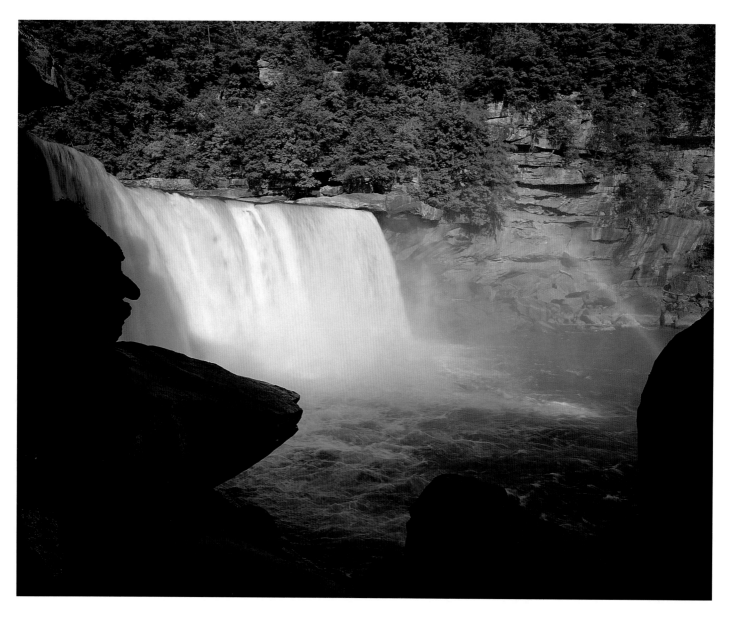

▲ Cumberland Falls, in Kentucky's Cumberland Falls State Resort
Park, drops sixty-eight feet and has a width of about 125 feet.
▶ Brookside Farms exhibits one of Kentucky's best-loved icons—
thoroughbred racing horses. The Kentucky Derby, which began in
1875 and continues at Louisville's Churchill Downs, is an annual
race for three-year-old thoroughbreds. The Triple Crown encom-
passes the Kentucky Derby, the Preakness, and the Belmont Stakes.

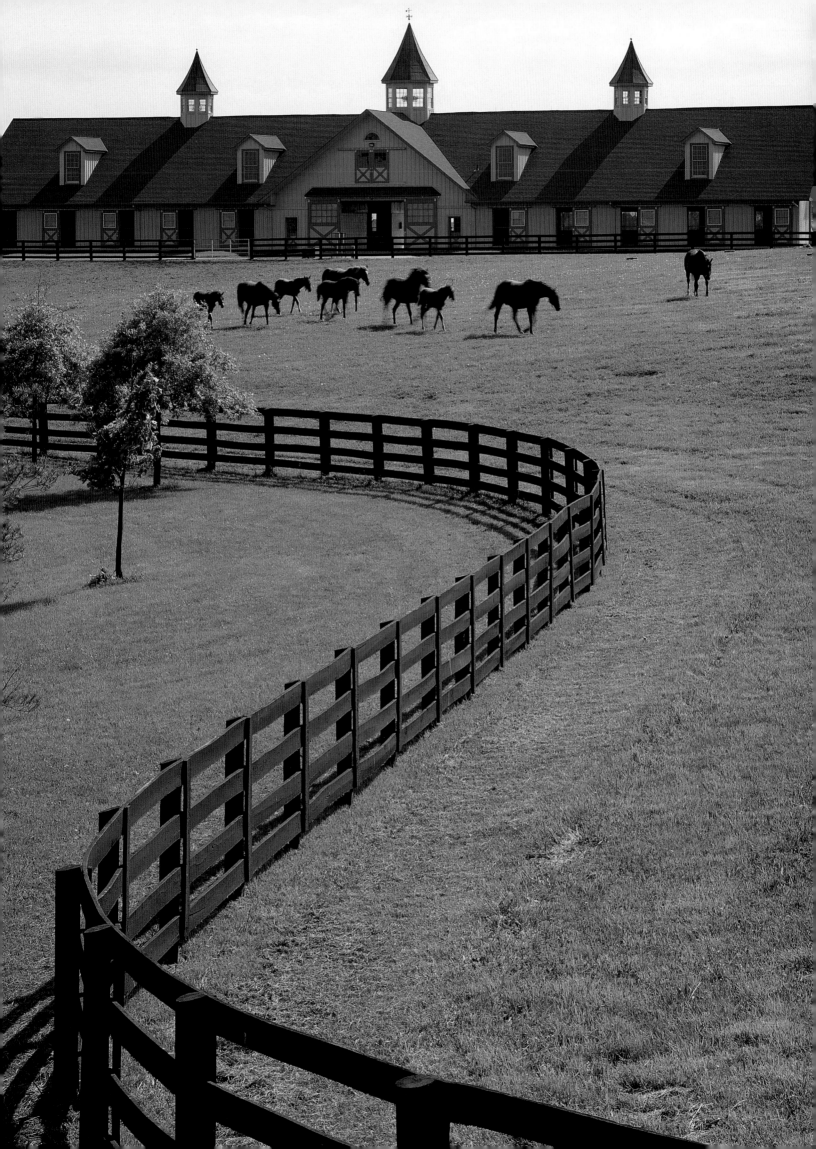

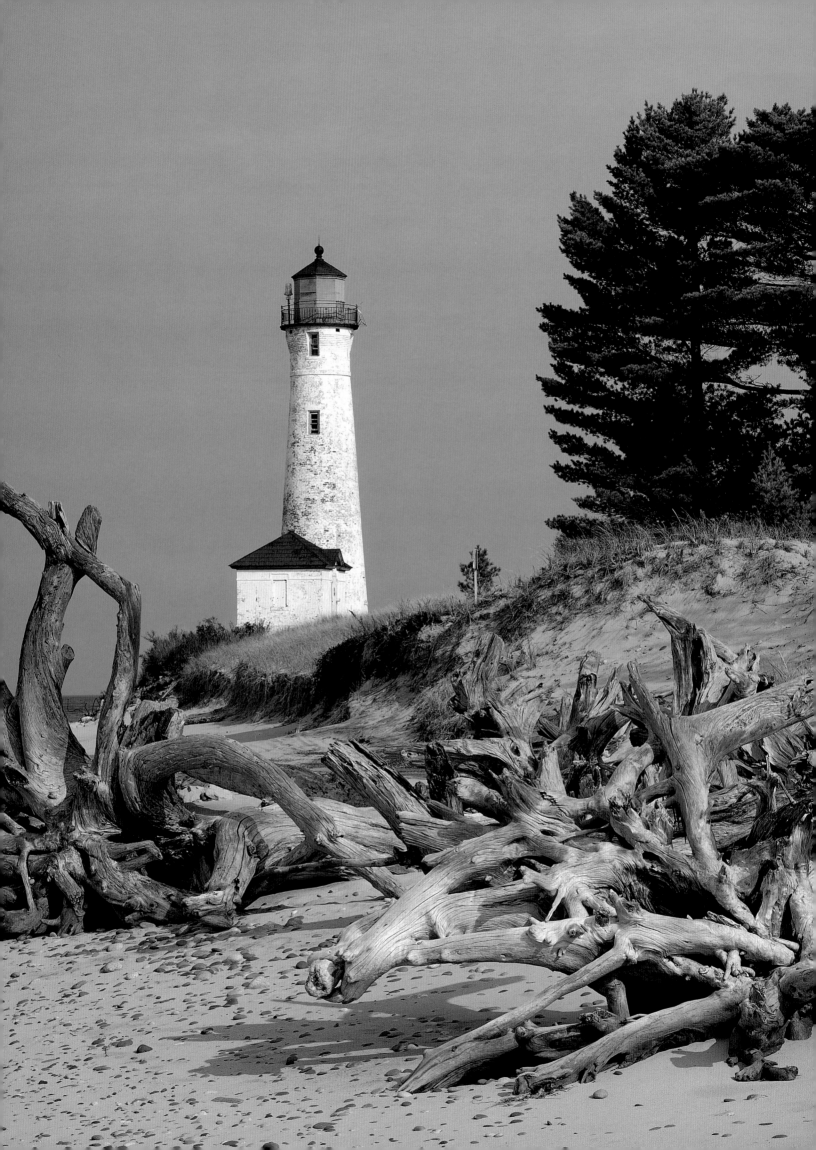

THE
GREAT LAKES

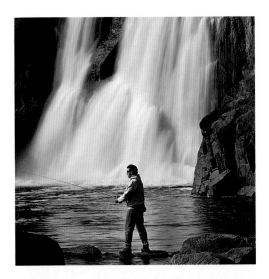

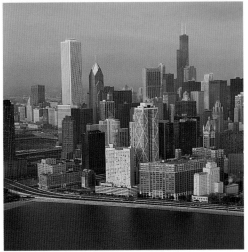

◄ *The Crisp Point Lighthouse stands in solitary splendor on Lake Superior's shore.*
▲ ▲ *A fisherman works the pool below the High Fall of the Baptism River, in the Tettegouche State Park of Minnesota.*
▲ *Chicago, situated on the shores of Lake Michigan, is a major center for finance, trade, manufacturing, and transportation.*
► ► *The Upper Tahquamenon Falls, over two hundred feet wide and dropping nearly fifty feet, have a recorded flow of more than fifty thousand gallons of water per second.*

Nearly ten percent of the world's fresh surface water lies in these five interlocking lakes. Covering thirty-two thousand square miles, they constitute the largest body of fresh water on earth. They are like oceans—water as far as the eye can see, ships passing on the horizon, and choppy waves lapping the sandy beach. Lake Superior, the largest, is cold even in August, because it is more than one thousand feet deep.

Strung like giant beads on the watery threads of the St. Lawrence Seaway to the east and the St. Croix and Mississippi Rivers to the south, the Great Lakes link the North Atlantic to the Gulf of Mexico. The basins, cut by receding glaciers, descend like a series of tipped bowls. Water spills lake to lake from Lake Superior, 602 feet above sea level, until it thunders over Niagara Falls into Lake Ontario and out the St. Lawrence.

The blue thread of another great river, the Ohio, defines the southern border of the Great Lakes region. The water network first drew explorers, then trappers and traders, to this area. The invention of the steamboat marked the beginning of an era of rapid growth for frontier towns like Cincinnati, which Longfellow called the "queen of the West." The rivers continued to be valuable highways as agricultural production grew and industry was built. The Ohio River, flowing through an industrial heartland of steel mills, factories, and power plants, still carries more tonnage than the St. Lawrence Seaway or the Panama Canal. Along the banks of the Ohio, the land is hilly and heavily wooded. Farther north, in the central farm belt, lies a fortune in corn, soybeans, alfalfa, and wheat. Agricultural promise drew homesteaders such as Abe Lincoln's family to states like Indiana and Ohio. As the frontier pushed west, pioneers discovered ever richer land.

North beyond the rich farms and dairies and orchards is the country of lumber and lakes. This is no place for the faint of heart. Winter temperatures often drop below zero and hover there. On the Upper Peninsula of Michigan, as much as three hundred inches of snow fall in winter, and the ground stays white well into spring. Compensation is the great natural beauty of the North Country, and the taste of unspoiled wilderness it offers. Wisconsin's fifteen thousand lakes and twenty-two hundred streams make it a fisherman's paradise. Minnesota's Boundary Water Wilderness, with its rugged forests and one thousand lakes, is the East's largest wilderness, after the Everglades.

Lumber legends were written in Great Lakes North Country. The forests of two-hundred-foot monarch pines on Michigan's Upper Peninsula built countless fortunes. In 1850, the trees were more valuable than California's gold, and the resource looked endless. By 1890, most had been cut. A few token groves remain, now protected.

Tracing a twenty-nine-mile curve along Lake Michigan's southwestern tip is the giant among lake cities—America's third largest. Chicago is called the "Windy City," both for the lake breezes and its politics, but Carl Sandburg may have characterized it best as the "City of Big Shoulders." It came of age as the rail head for massive cattle drives in the early 1800s, built industrial muscle with meat packing and steel, and gathered financial clout in the grain trade. It remains a transportation hub; O'Hare Airport is the busiest in the world.

Birthplace of the school of architecture that inspired Frank Lloyd Wright, Chicago is as expansive and horizontal as New York is vertical and intense. It is vigorous, direct, thoroughly Midwestern. Even as it faces the Lake, it sprawls westward, mirroring the character of the prairies it introduces.

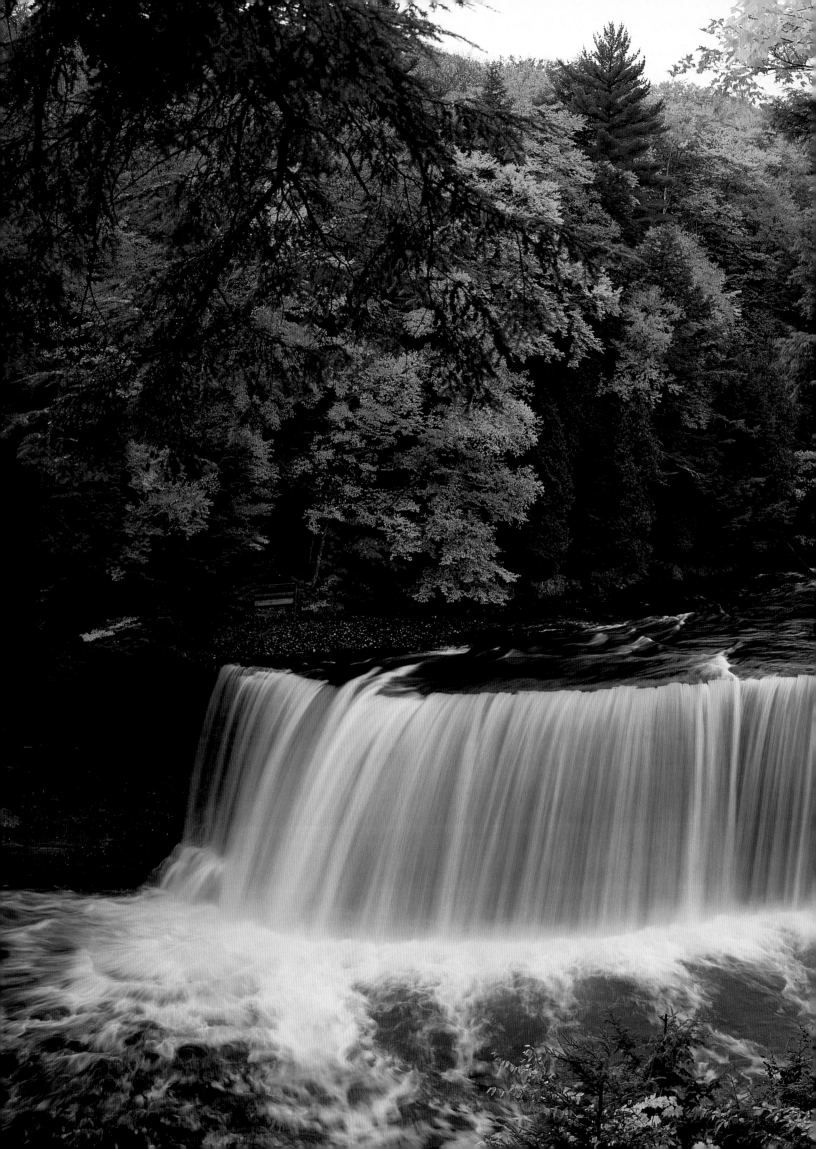

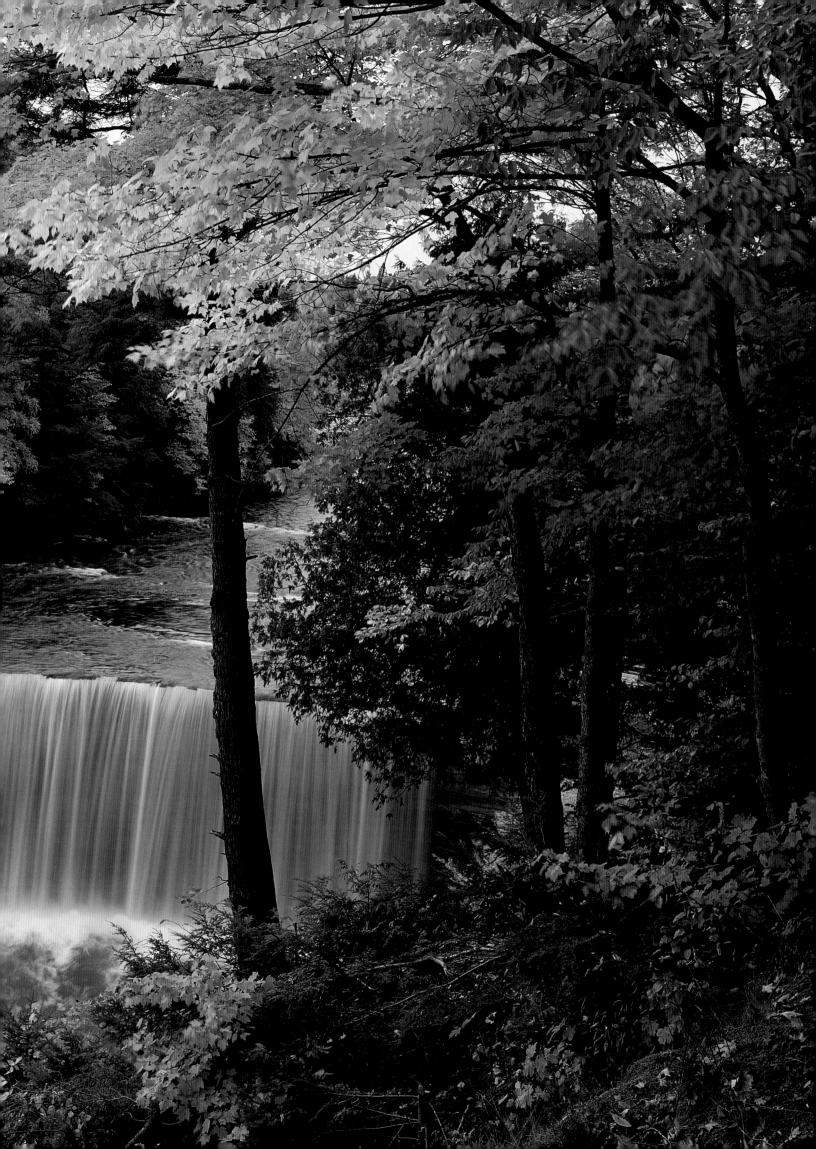

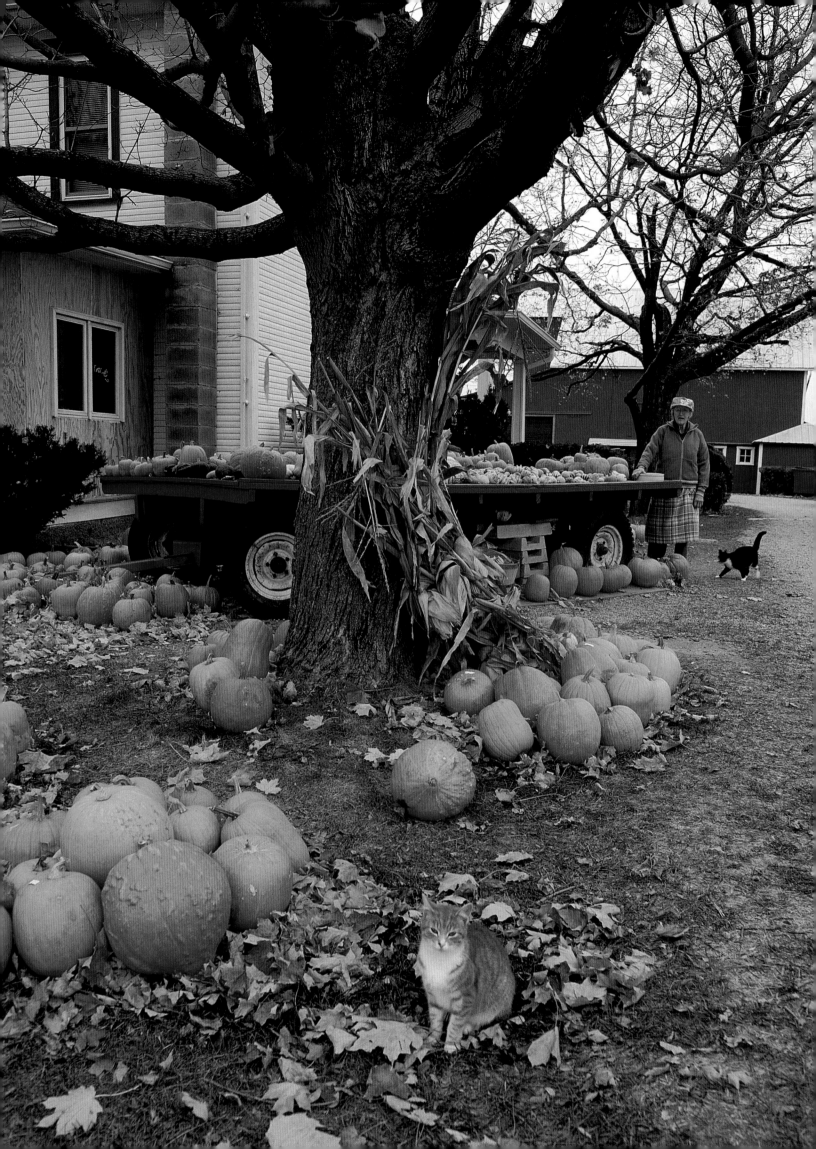

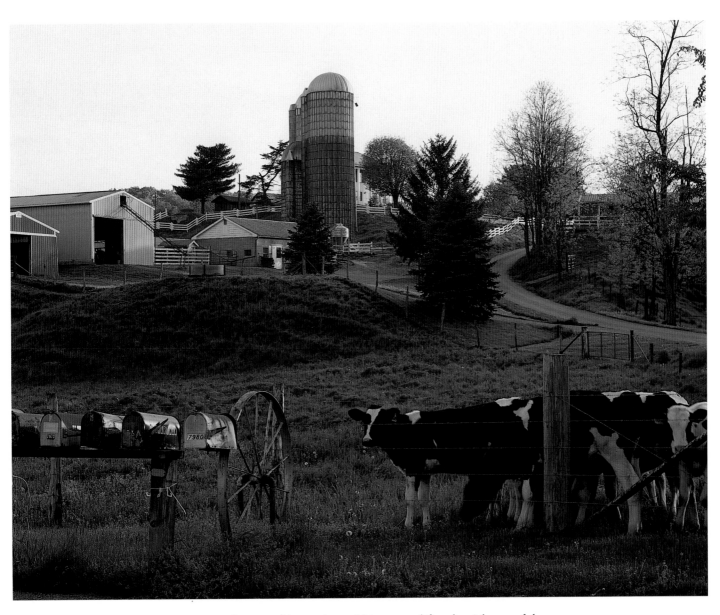

◄ A pumpkin stand in northern Ohio exemplifies the richness of the produce available in rural America, as well as the festivities, such as Halloween, that make up such a large part of the fabric of America. ▲ Much of Ohio is known for its dairy, soy bean, corn, hay, and wheat farming; its livestock production includes cattle, broilers, pigs, and turkeys. With a population of more than eleven million, Ohio's principal industries are trade services and manufacturing.

43

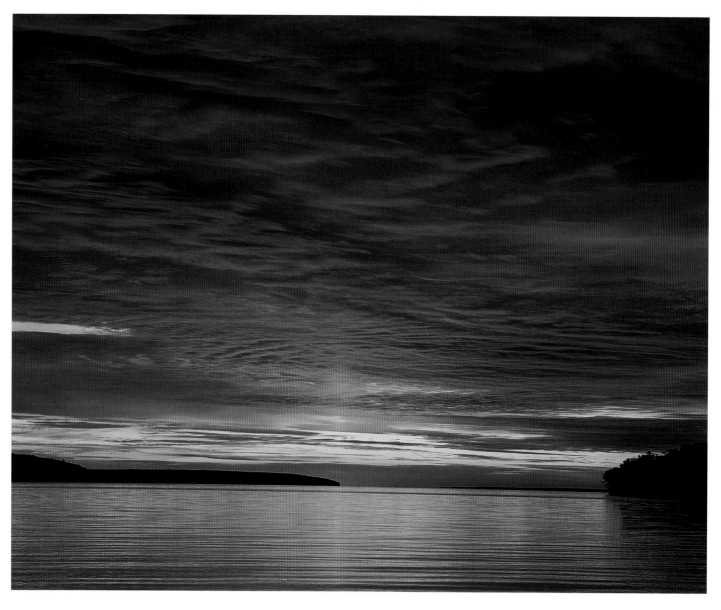

▲ Frog Bay, situated on Lake Superior, is part of the Red Cliff Indian Reservation and Apostle Islands National Lakeshore of Wisconsin. Also known as the Ojibwa, the Chippewa who call this area home are part of one of the larger tribes north of the Mexican border.
▶ Manido Falls are only one of the gems to be found on the Presque Isle River in Porcupine Mountains Wilderness State Park, which was established in 1945 in the Upper Peninsula of Michigan.

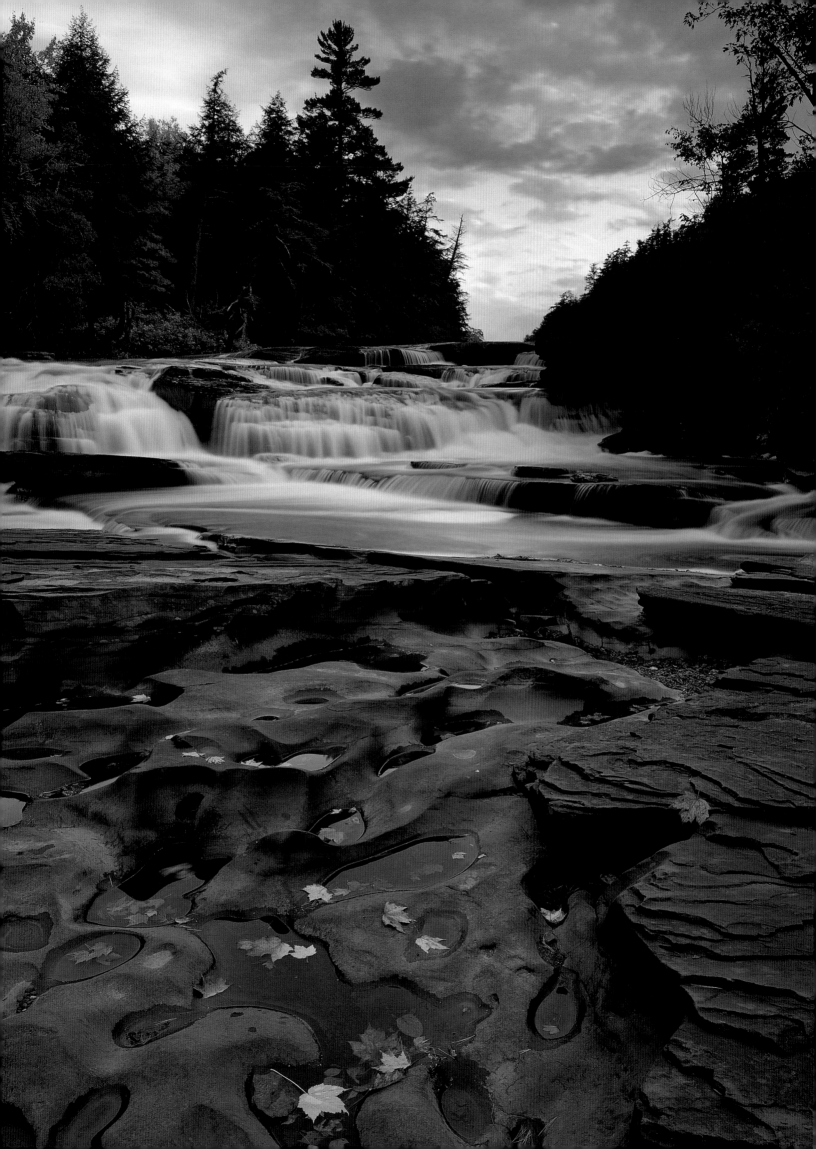

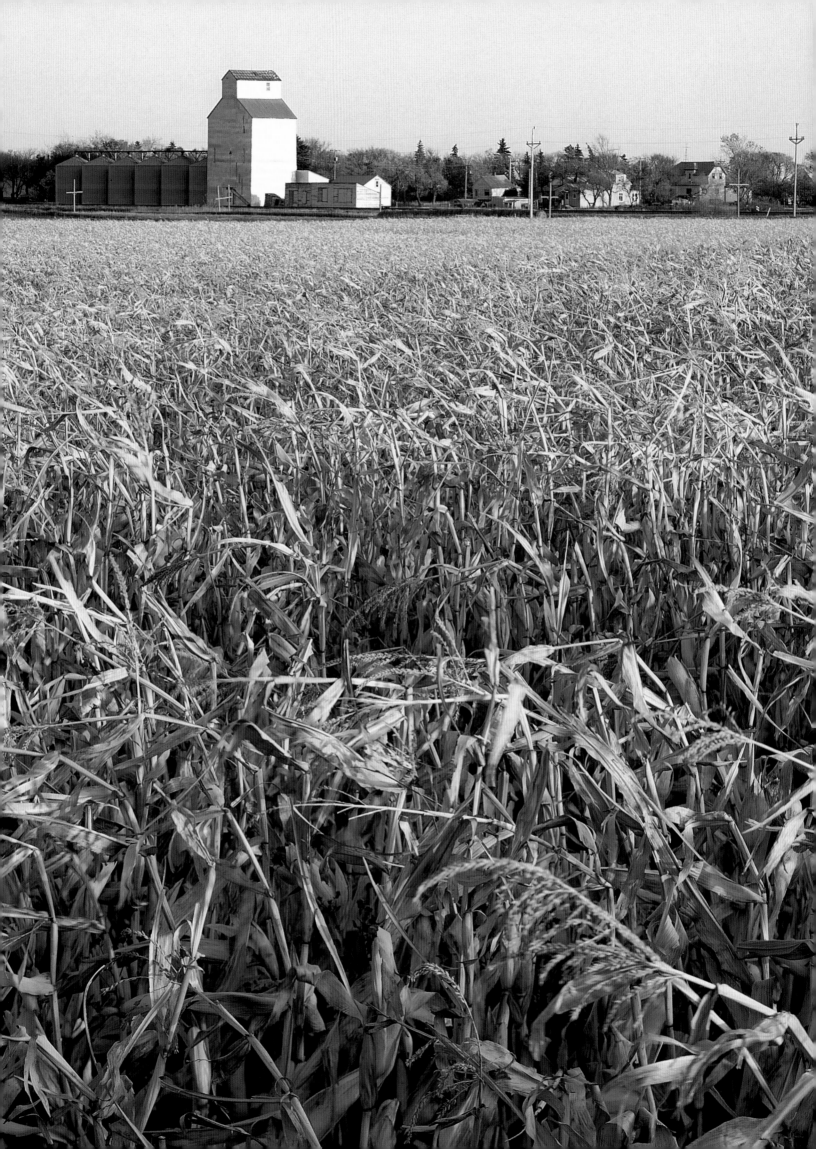

THE
HEARTLAND

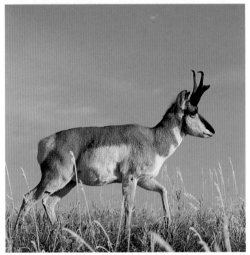

◄ A cornfield and a grain elevator in Mapes, North Dakota, exemplify land uses in the plains. Forests cover less than 10 percent of the plains, leaving massive space for crop and livestock production. ▲ ▲ Plots of nursery stock and fields of wheat, corn, and hay present an agricultural tapestry across America's breadbasket. ▲ Pronghorn antelope range in South Dakota's Badlands National Park. Speeds up to sixty miles per hour make them the fastest land animals in North America.

A chunk of rusty armor in a Lyons, Kansas, museum bears testimony to the fact that Coronado and his conquistadors rode that far in 1541, chasing a myth about seven cities of gold. They were disappointed. They found only endless grassland, grazed by vast herds of the thin-shanked, long-horned, bearded beasts we call buffalo. Sixty million American bison roamed the plains then, in herds large enough to drink whole rivers dry. The agile Natives who hunted them—on foot, with spears and arrows—were also the fiercest warriors on the continent. The Spanish introduced them to horses and guns.

French trappers and explorers laid next claim to the plains. When Jefferson tried to buy New Orleans in 1803, Napoleon, in need of money, insisted on selling the entire Louisiana Territory. Congress reluctantly voted fifteen million dollars for the land between the Mississippi and the Rockies. They felt they already had enough land: the great, treeless plains were useless for agriculture, anyway. On an 1820 map, the plains were labeled "The Great American Desert."

When pioneers did cross the Mississippi, they found not a desert, but a sea of grass, deep as a man was tall. The tallgrass prairie rolled out all the way to eastern Kansas, and its deep roots created soil so dense that homesteaders often broke their plows trying to turn it. Plow it they did, though.

It was not easy. Pushing westward, the wagon trains left a trail of possessions and grave sites. Homesteaders fought Indians, tornadoes, locusts, dust, and loneliness. Dugouts and sod houses where they weathered Nebraska winters are an example of those early settlers' tough pragmatism.

In the prairie, corn now grows taller than a man's head, in mile after mile of green fields. Beyond the corn belt, amber waves of grain ripple to the horizon, and fat beef cattle graze. The "desert" is America's breadbasket and steak platter.

It is a common misconception that the prairies are flat. The central plain actually slopes up to the west, gaining five thousand feet from the Mississippi to the Rockies. It also ripples with hills, from Missouri's Ozarks to the lake-filled Flint Hills of Nebraska. Precipitation diminishes, east to west. Iowa, the nation's leading corn producer, receives about thirty inches of rain a year, while Nebraska gets fifteen. Rainfall dictates transitions in crops, as it did the length and profusion of prairie grasses.

St. Louis, the French-founded port on the Mississippi, was the gateway for westward immigration and inspiration for Mark Twain's stories. Kansas City, on the mighty Missouri River, was built by the railroads and the meat packing industry. To tell the tales of towns like Abilene and Dodge City would take another book. But cities and sagas are not what this region is about.

It is about the land.

From a plane, it spreads below like a giant quilt. Country roads define the miles, in a grid that is the legacy of Jefferson's town and range system. The fields make a pattern of green and gold and rich black earth, their angles overlaid with the perfect circles scribed by giant sprinklers. A barn, a house, and a clump of trees pin down one corner of each farm spread. The pattern is broken, occasionally, by a winding stream edged with cottonwoods, or a town marked by a water tower and a tall grain elevator.

It is about broad vistas, green fields, and miles of road. It is about hard work and home-grown values, elbow-room and independence, blizzards and forked lightning and sunflowers six feet tall. It is about seeing for miles in every direction—and feeling both very powerful and very small.

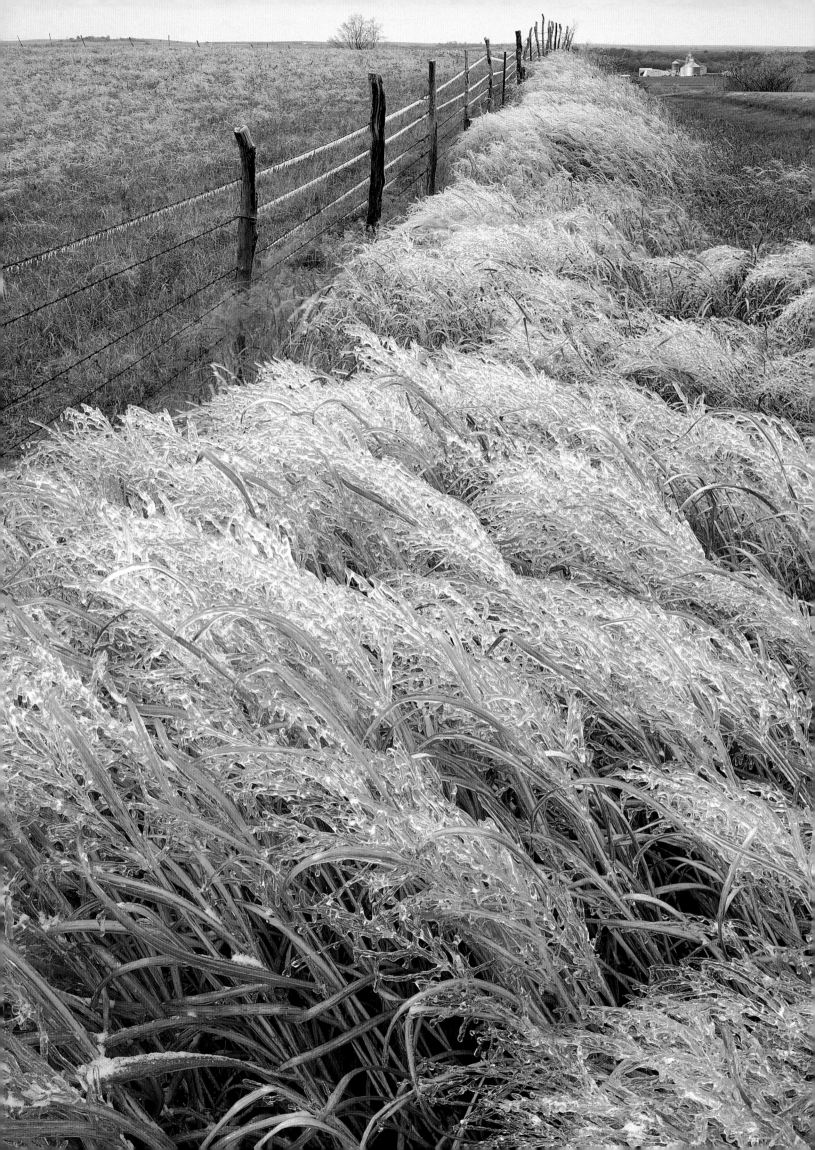

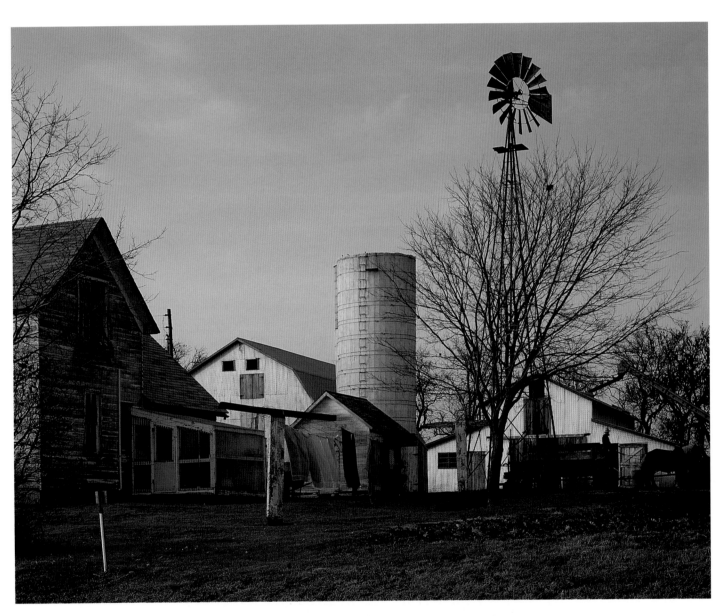

◄ Winter ice coats the grass and fence near Osage City in eastern Kansas. Kansas was explored by Francisco de Coronado for Spain, and by Sieur de La Salle for France, more than a century before it was ceded to the United States as part of the Louisiana Purchase in 1803.
▲ Noted for traditional ways, the Amish of Iowa live chiefly by farming. Home church services and barn raisings show community spirit.

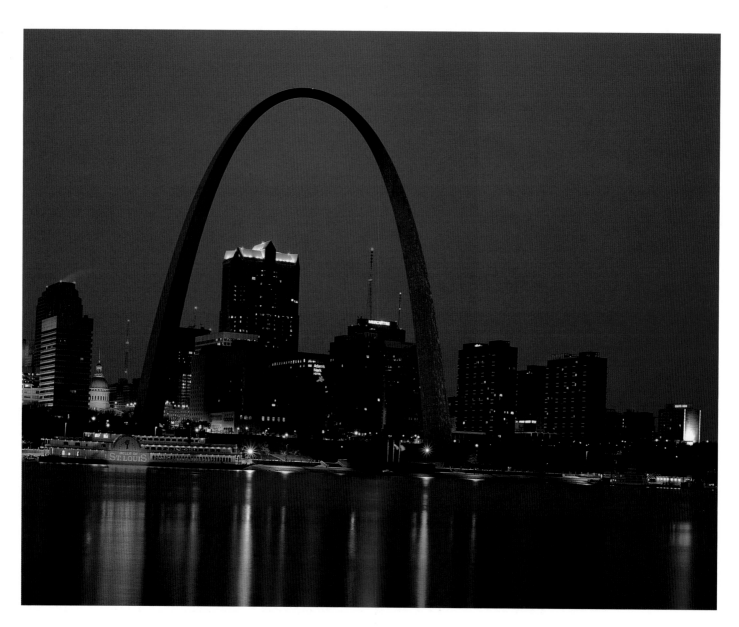

▲ The Mississippi River was labeled early on as the Gateway to the West. Today, the Gateway is marked by the Jefferson National Expansion Memorial Gateway Arch of St. Louis.
► Now preserved in Ozark National Scenic Riverways, Missouri, Alley Spring Mill was a vital link to survival of the area's people.
►► Badlands cover some six thousand square miles of Nebraska and South Dakota. Many fossilized bones have been found in the area.

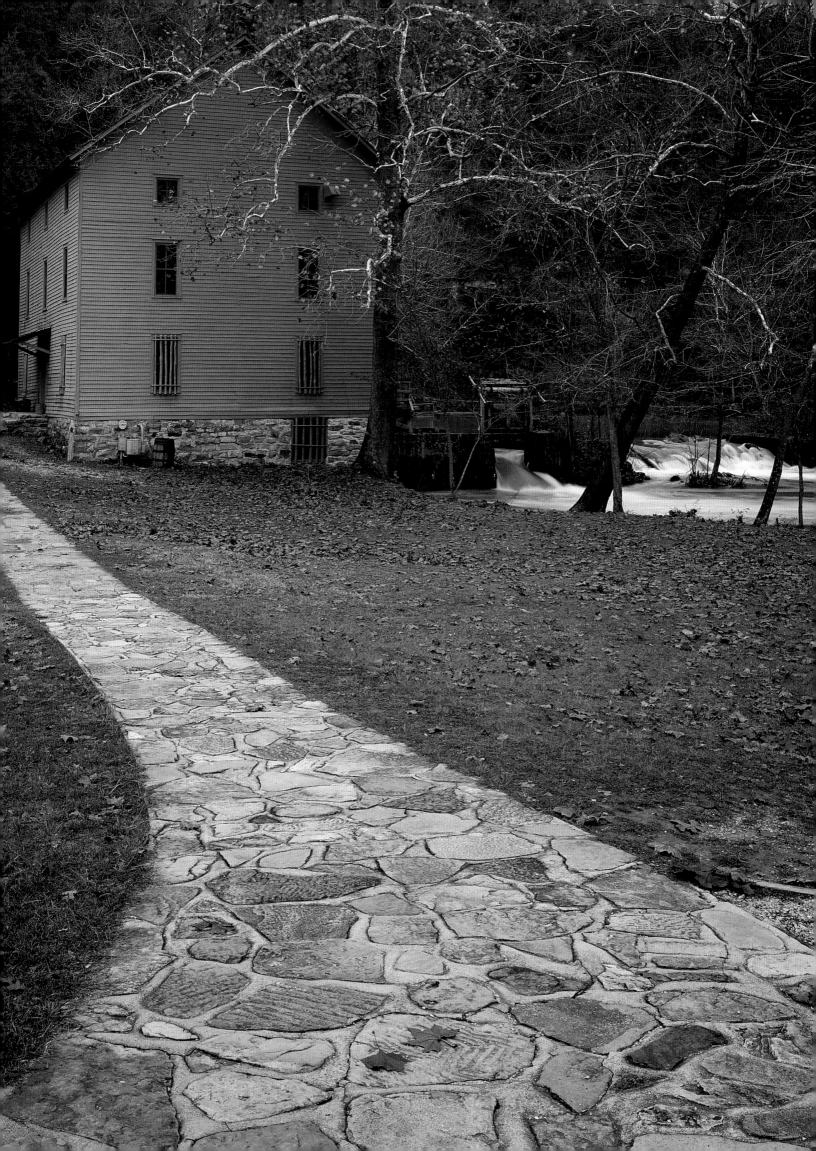

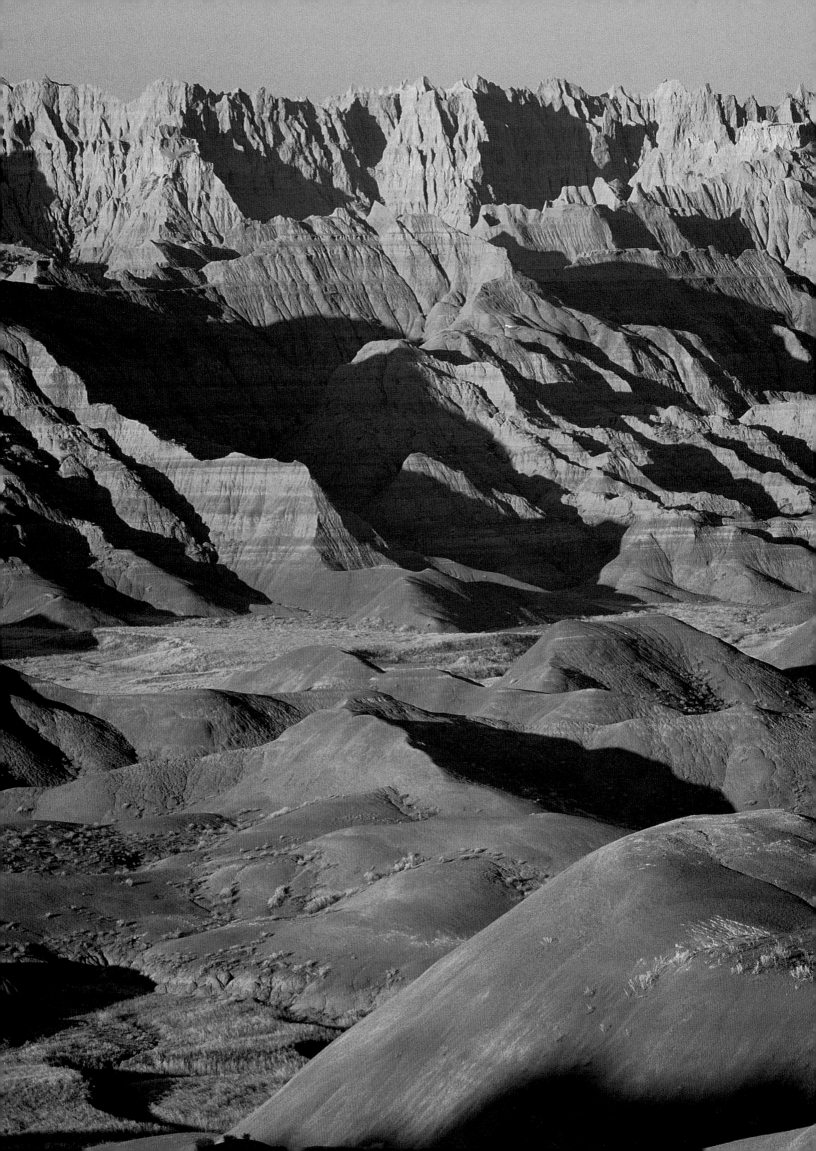

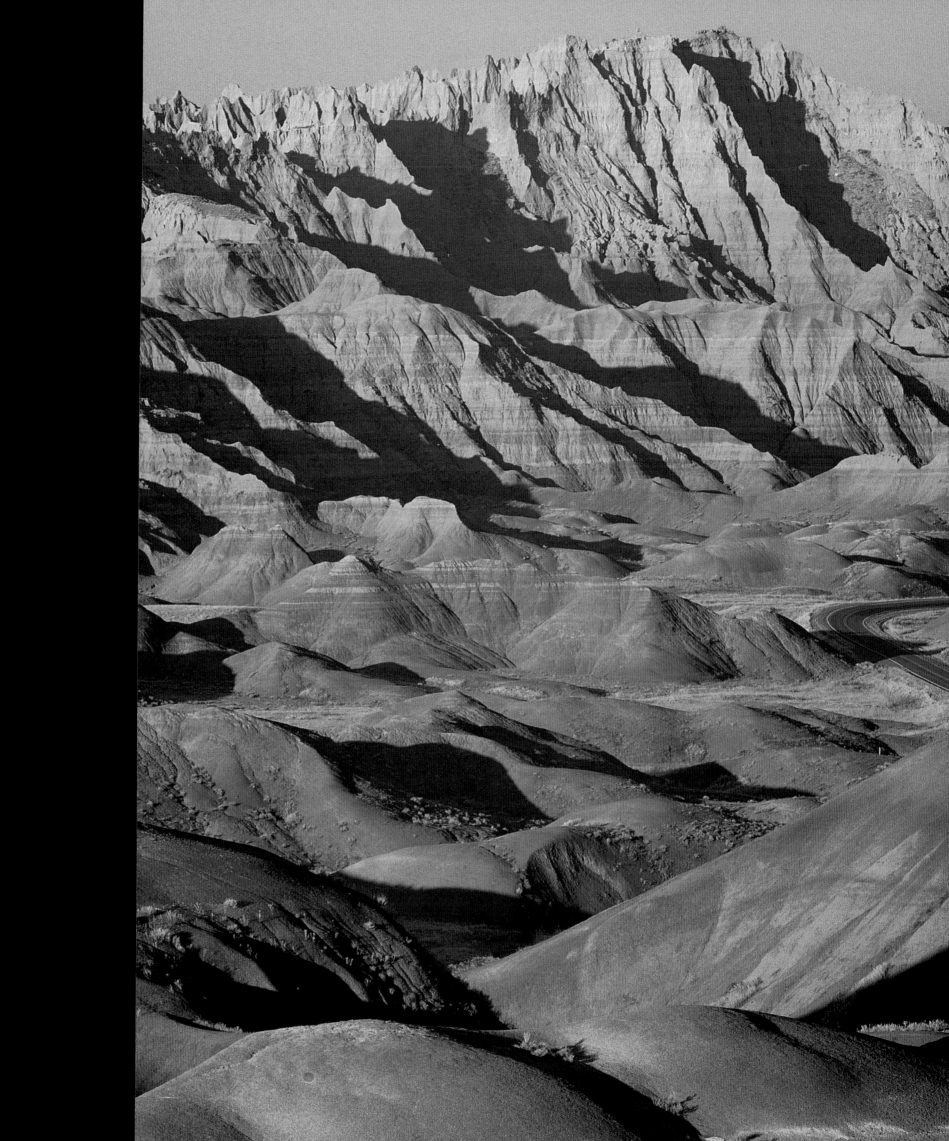

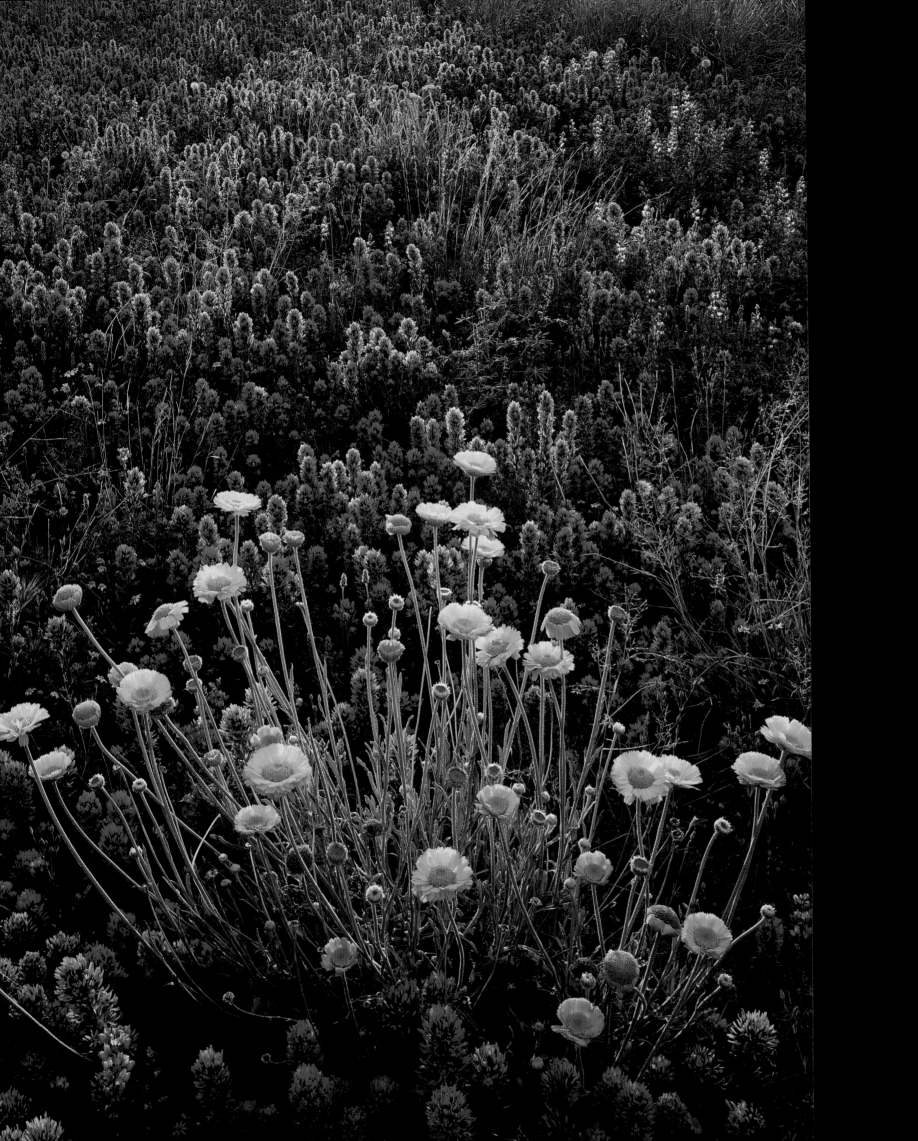

TEXAS
&
THE SOUTHWEST

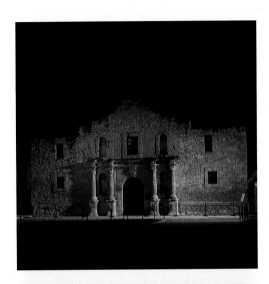

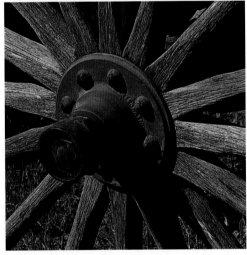

◄ *The right combination of winter and spring rains triggers a lush show of desert marigold and owl's clover on the Tohono O'odham Reservation in southern Arizona.*
▲ ▲ *The Mission San Antonio de Valero, better known as the Alamo, was founded in San Antonio in 1718. Besieged in 1836 by Santa Anna, it was defended to the death by less than two hundred Americans, including Davy Crockett and Jim Bowie.*
▲ *Near Fredericksburg, a wagon wheel gives evidence of the rich history of Texas.*

Out of these wide open spaces rode one of America's favorite icons—the lone cowboy. Making his stand in its canyons, silhouetted on its mesas, galloping off into its flaming sunsets, he made this landscape familiar to generations of movie-goers.

The cowboy was real enough, after all, even if some of the tales got out of hand. The first buckaroos were working the big ranches along the Rio Grande in the seventeenth century, when Spain claimed a grand swath of the western continent. The cowboy evolved as the territory changed hands.

After the Revolution of 1821, Spain ceded the land to Mexico. Soon after, Texas' Anglo settlers staged their own revolution and fueled the Western legend with their stand at the Alamo. Texas flew its own flag for nearly a decade, making it the only state that was once a sovereign nation. Cowboys were still herding Easterners' future steaks up the Santa Fe Trail when The Lone Star State joined the Union in 1845.

A simple invention helped mark the end of that flamboyant era. Barbed wire, introduced in 1874, ended the open range and closed up the "wide open spaces." Soon after, the railroad arrived and eliminated the need for cross-country cattle drives. Billy the Kid bit the dust at the OK Corral, and Geronimo and his fellow Apaches surrendered. By 1912, when Arizona and New Mexico rounded out the original forty-eight states, the Wild West had been tamed.

That was virtually yesterday in the scope of this region's long history. When the first Spanish explorers arrived in the early 1500s, Native people had been dwelling among its cliffs and canyons for centuries. The mysterious Anasazi culture, which left its traces throughout the "Four Corners" area, was at its zenith during Europe's Middle Ages. And it was probably a grand, sun-struck adobe pueblo that lured Coronado in search of the seven cities of gold.

To talk of cowboys, Spaniards, Mexicans, or even the ancient Anasazi is only to touch the surface. The great, arid Southwest puts people in perspective. Vast and solitary, over-arched with immense skies, its vistas speak of timelessness and inspire words like magical and mystical. In its rugged topography, nature is stripped down to the bones, and earth's history is laid out to be read.

The paradox, in this dry land, is that water had been a fundamental shaping force. Ancient seas laid its soft sedimentary rock. Powerful rivers and persistent streams have carved its spectacular caverns and canyons. It is a geologist's paradise: two billion years of creation are revealed in the walls of the heart-stopping, mile-deep Grand Canyon.

With its austere landscape, mineral colors, and unique light, the Southwest casts a powerful spell, captivating artists like Georgia O'Keeffe and beckoning writers like D. H. Lawrence. But that is hardly to say it all looks alike. It is a long way from the delicate desert flowers in Arizona's baking deserts to Texas' desolate Trans-Pecos. And the streams and forests of east Texas are almost another country away. As any resident would be quick to remind you, Texas is bigger than most European nations and contains everything from sub-tropical ranch lands to sandy Gulf beaches.

Diverse as it is, this sprawling section of the country shares some common characteristics. Throughout Texas and the Southwest, a blend of Spanish, Mexican, Native, and Anglo gives the culture special flavor and color. This region shares a common heritage, colorful history, striking topography—and lots and lots of space.

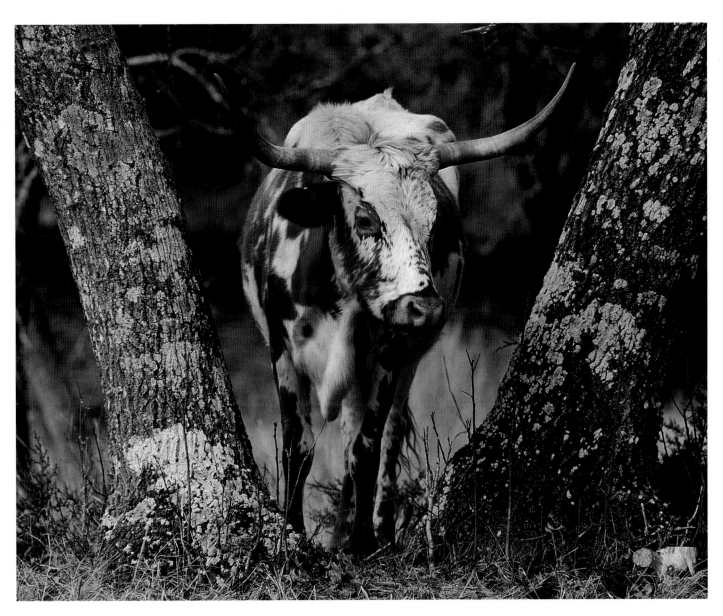

◀ Texas is represented by various symbols: the bluebonnet shines as the state flower; the mockingbird sings as the state bird; the pecan stands as the state tree; and friendship reaches out as the state motto.

▲ Texas longhorns were brought from Spain by Columbus. By 1866, herds arrived from Mexico and flourished on the South Texas prairies. The hardy longhorns, of critical importance to early ranching, influenced nearly all development in Texas and the Southwest.

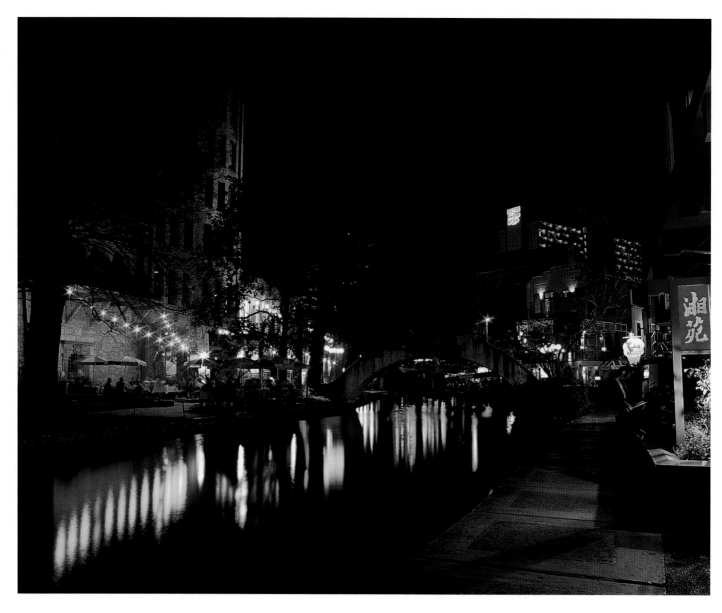

▲ The River Walk, or Paseo del Río, borders the San Antonio River. Picturesque paddle boats glide by shops, restaurants, and hotels in this promenade in San Antonio, a city of more than a million.
► Home-canned products are displayed at the Sauer-Beckman Farmstead, part of the Lyndon B. Johnson State Historical Park.
►► The Grand Canyon is a mile deep, 18 miles wide, and 277 miles long. Some of the world's oldest exposed rock is at the bottom.

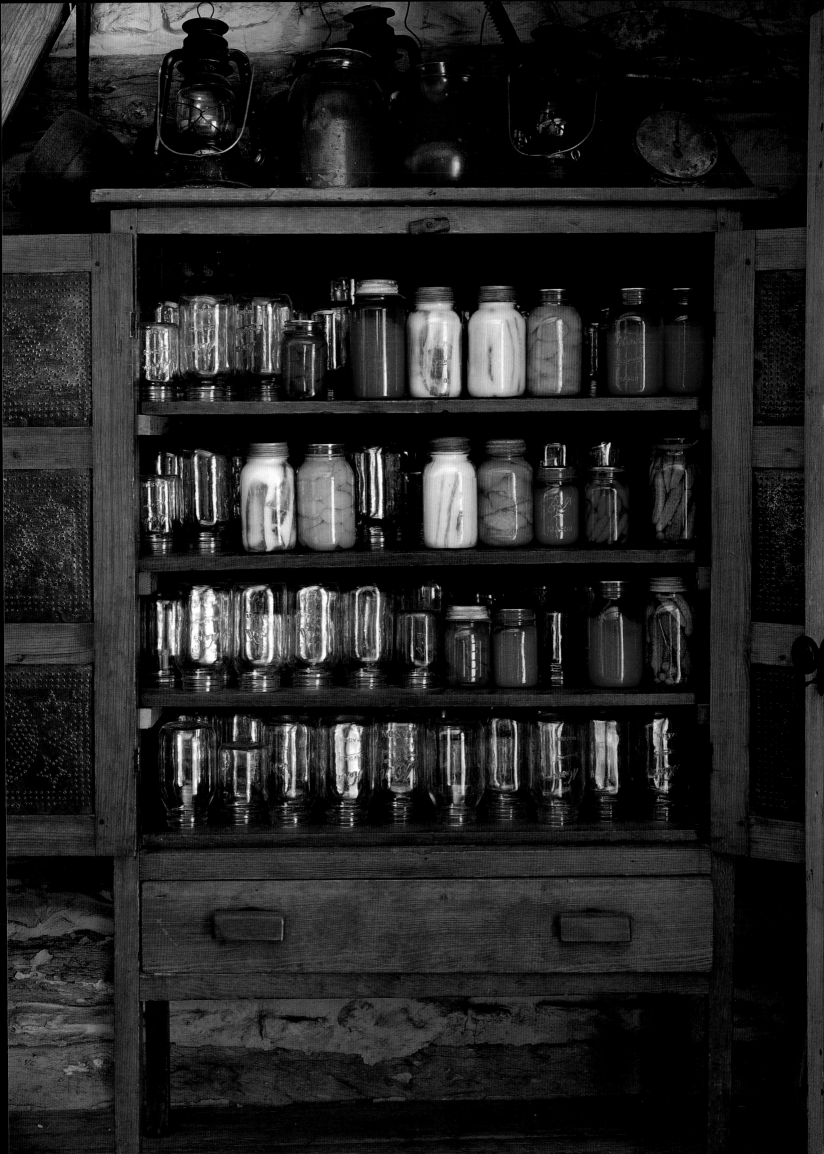

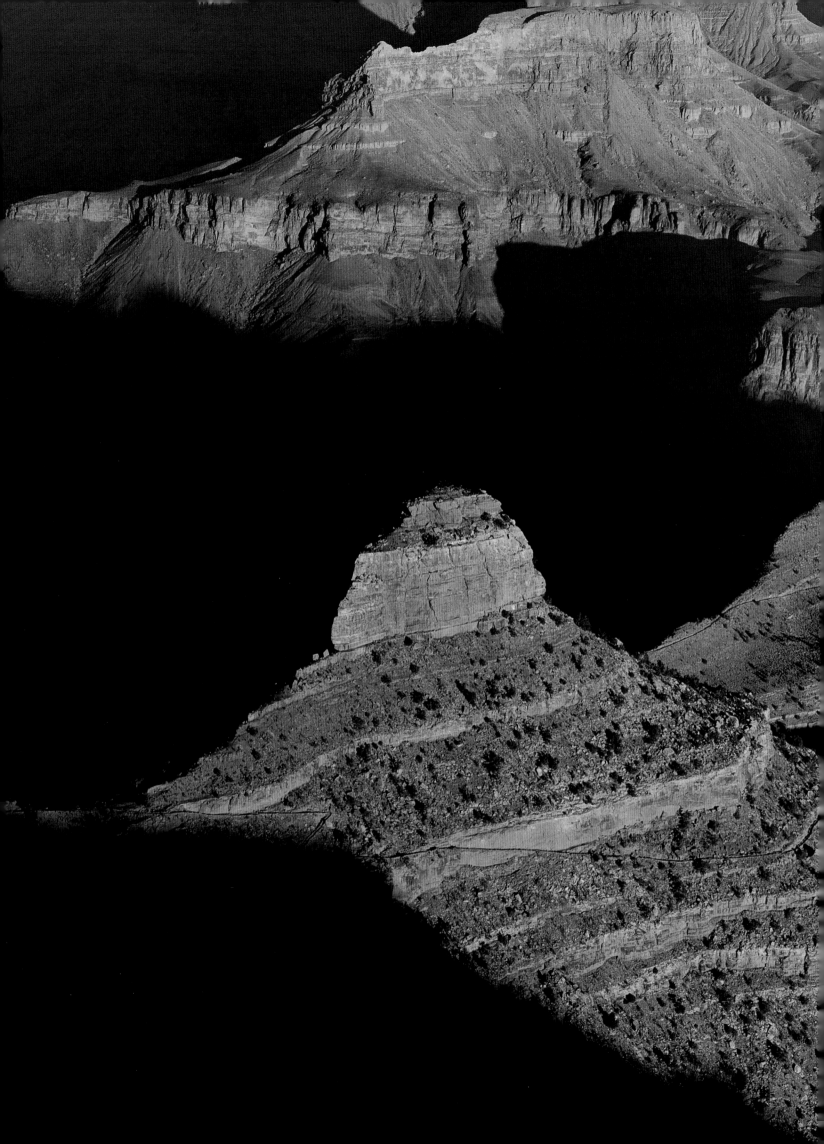

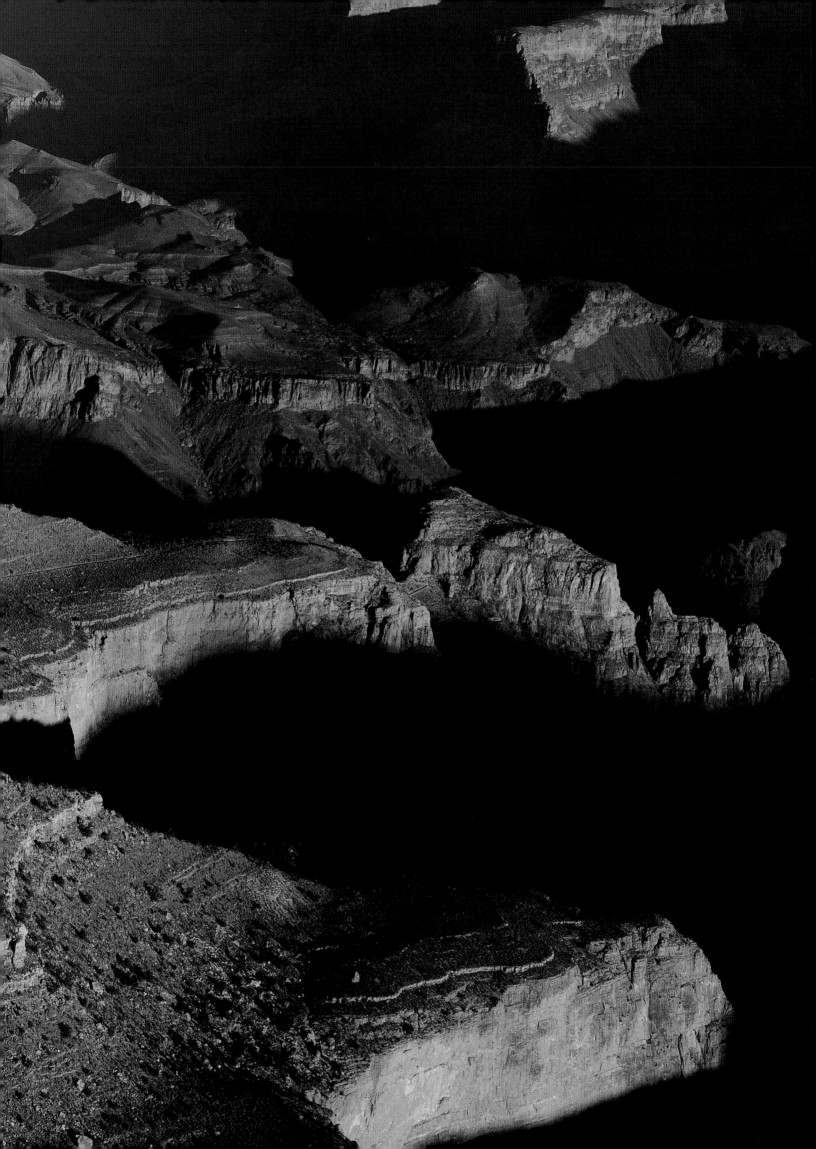

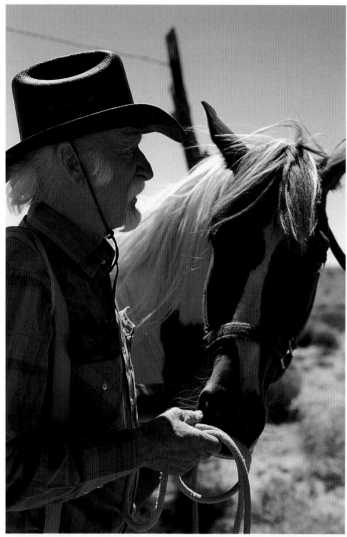

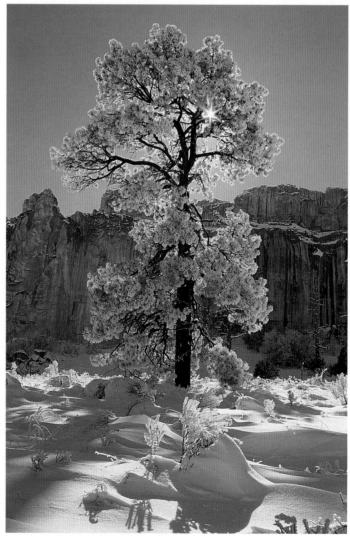

▲ *Clockwise:* Cowboys are part of America's past and present; a juniper survives in Utah's Escalante River Basin; a ponderosa pine reaches skyward at El Morro National Monument; Carla Goseyun takes part in an Apache Sunrise Ceremony.
▶ The saguaro, monarch of the Sonoran Desert, is the world's largest cactus, reaching as high as sixty feet.

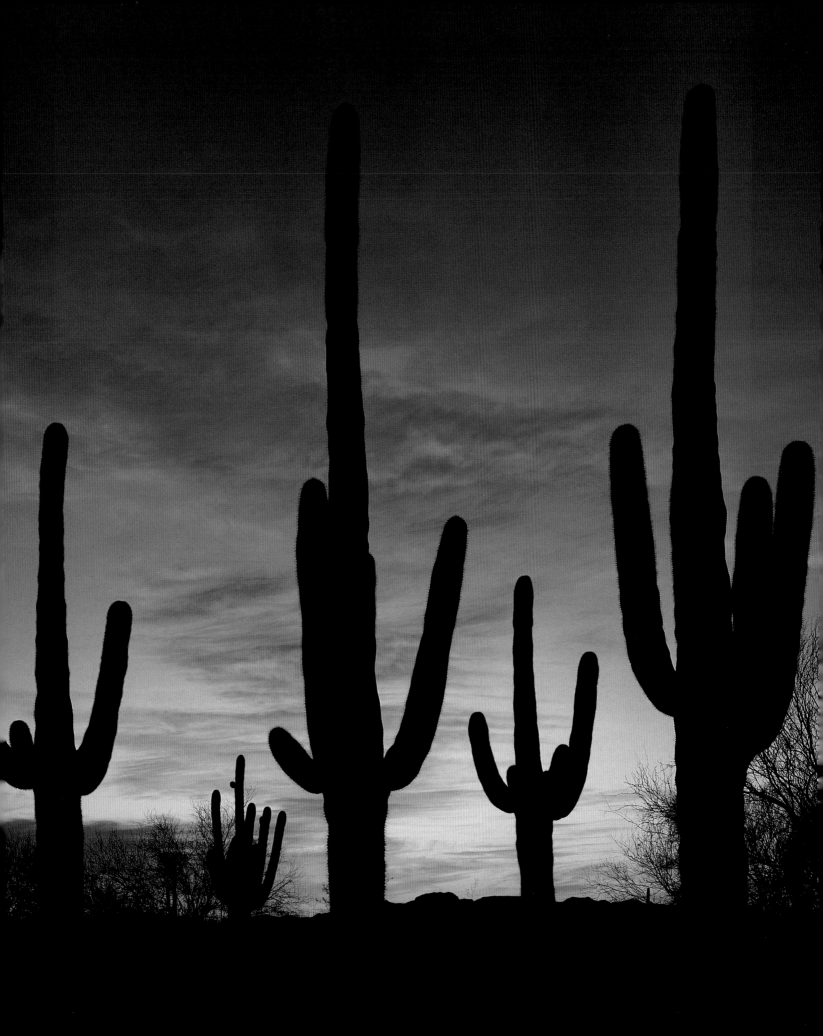

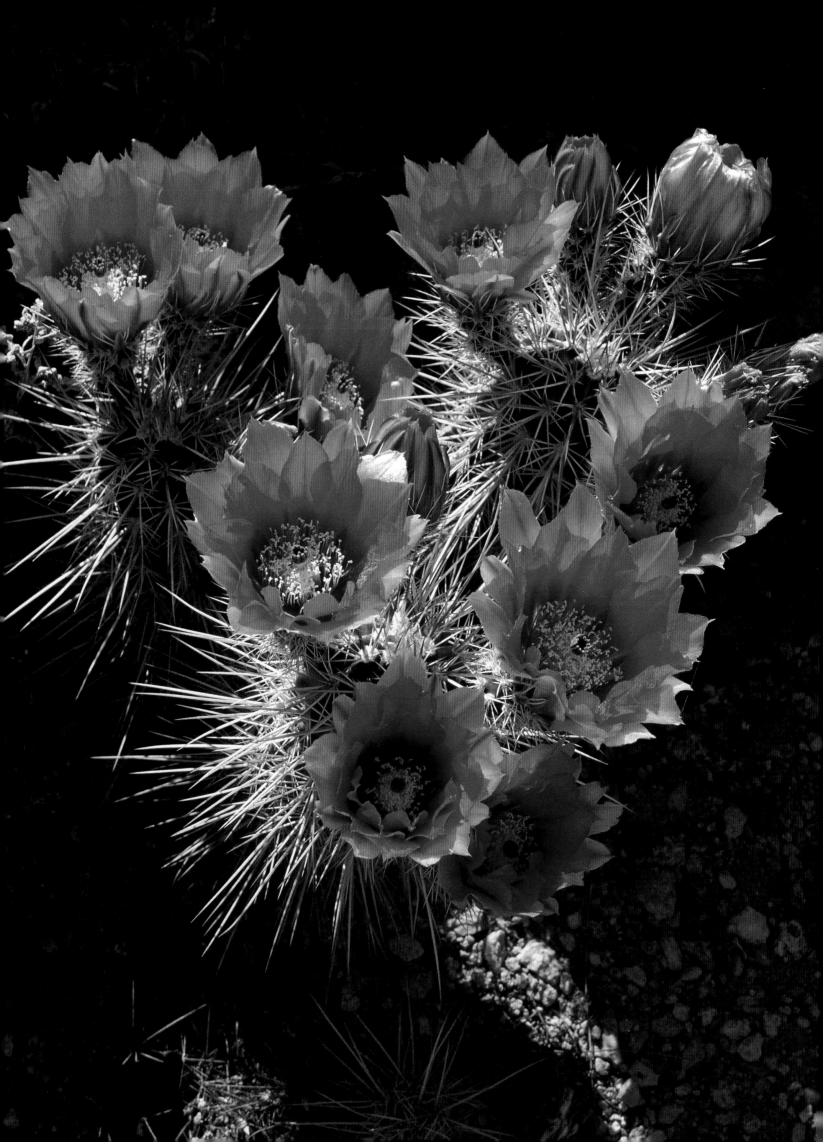

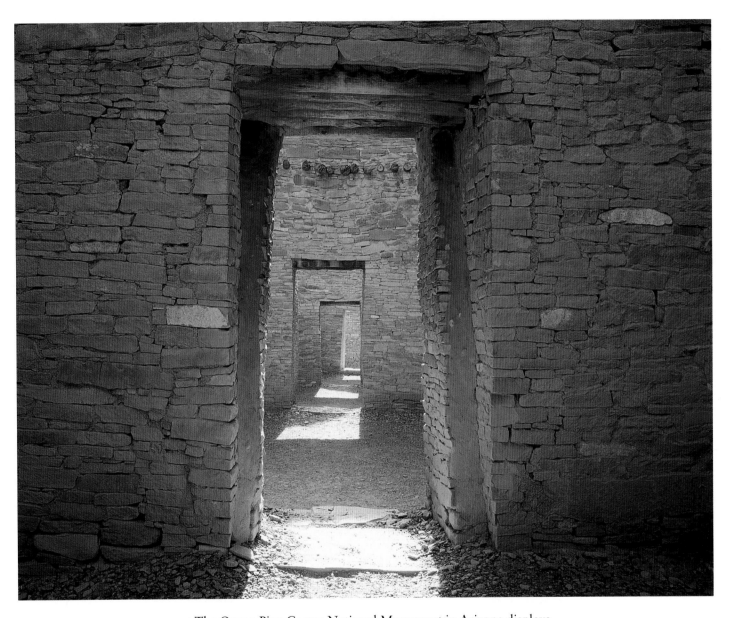

◄ The Organ Pipe Cactus National Monument in Arizona displays
the brilliant blooms of hedgehog cactus, *Echinocereus engelmannii*.
▲ Masonry and doorways inside Pueblo Bonito, at New Mexico's
Chaco Culture National Historical Park, evidence careful planning.
Likely the largest Anasazi structure ever built, Pueblo Bonito con-
tained about eight hundred rooms built of mud, rock, and poles.

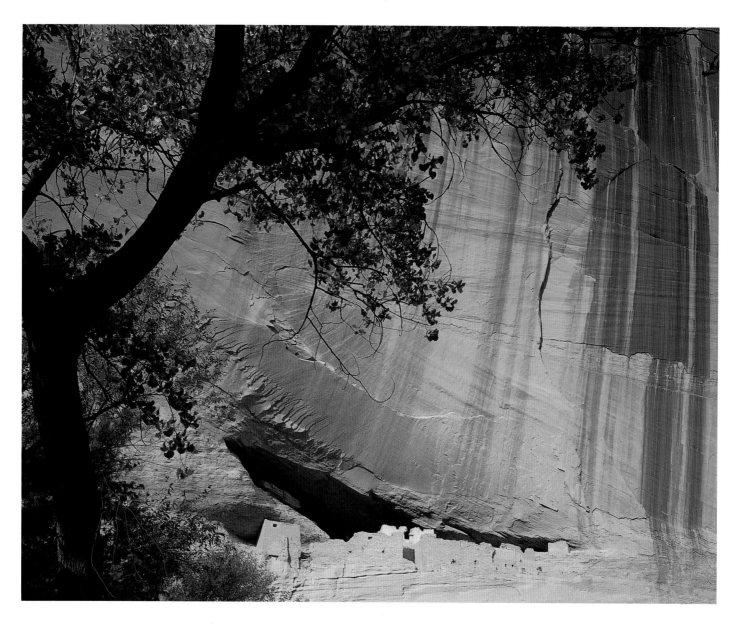

▲ White House Ruin is an ancient Anasazi dwelling in Arizona's Canyon de Chelly National Monument. These canyons sheltered Pueblo people for centuries and later served as a Navajo stronghold.
► Volcanic dust from the Philippine eruption of Pinatubo Volcano casts an alpenglow on Delicate Arch, in Utah's Arches National Park.
►► West Mitten Butte towers above the plain in Monument Valley, which spans the Utah-Arizona border on the Navajo Reservation.

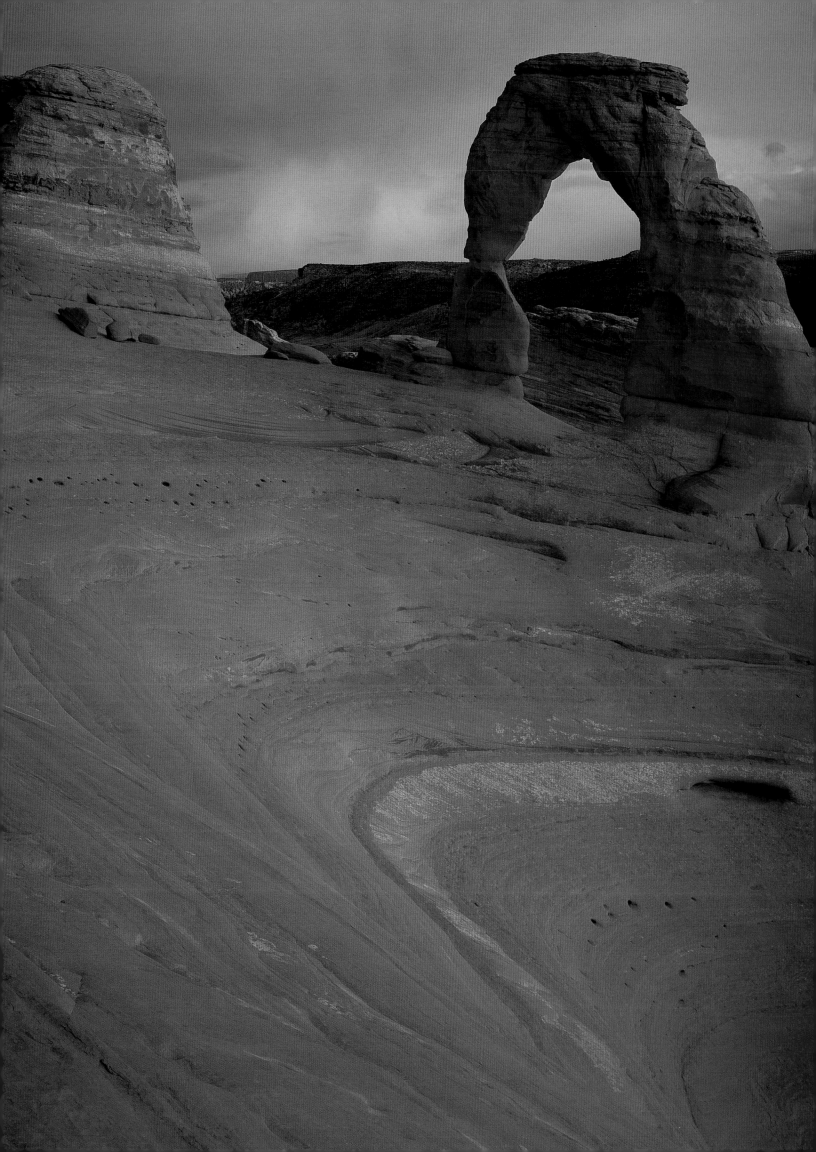

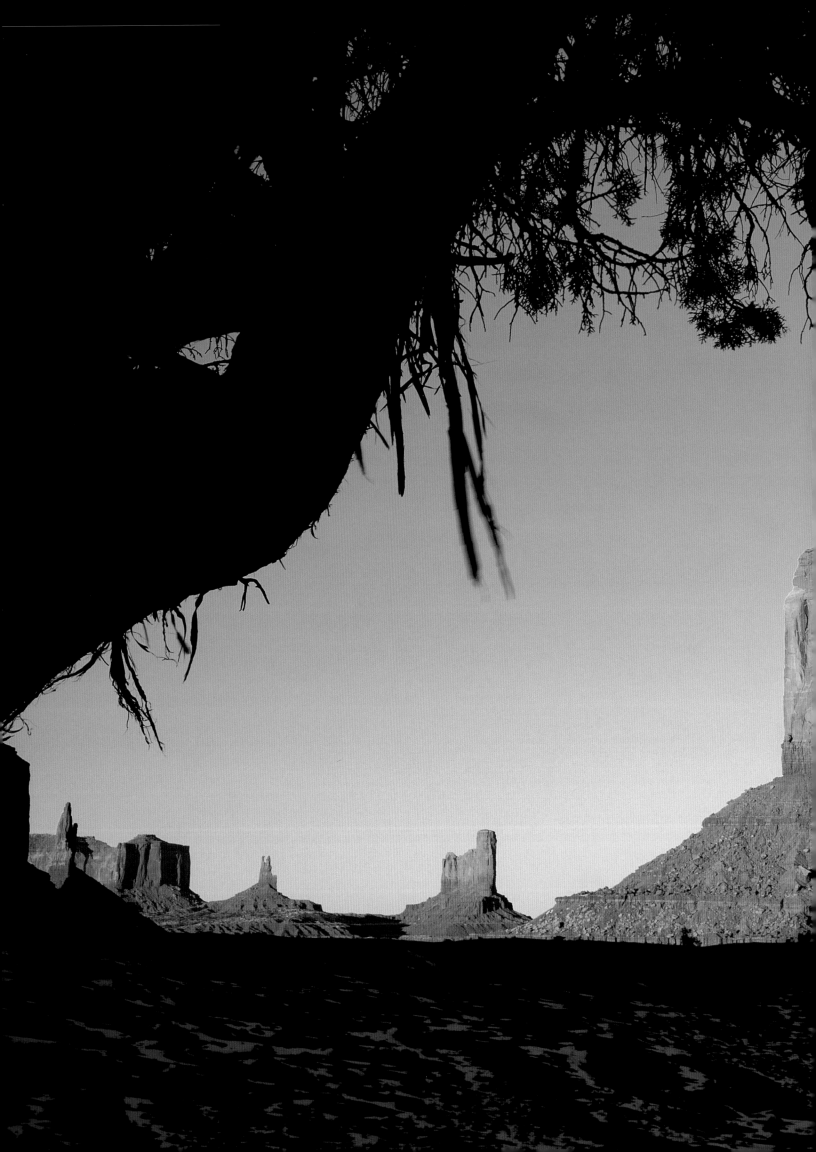

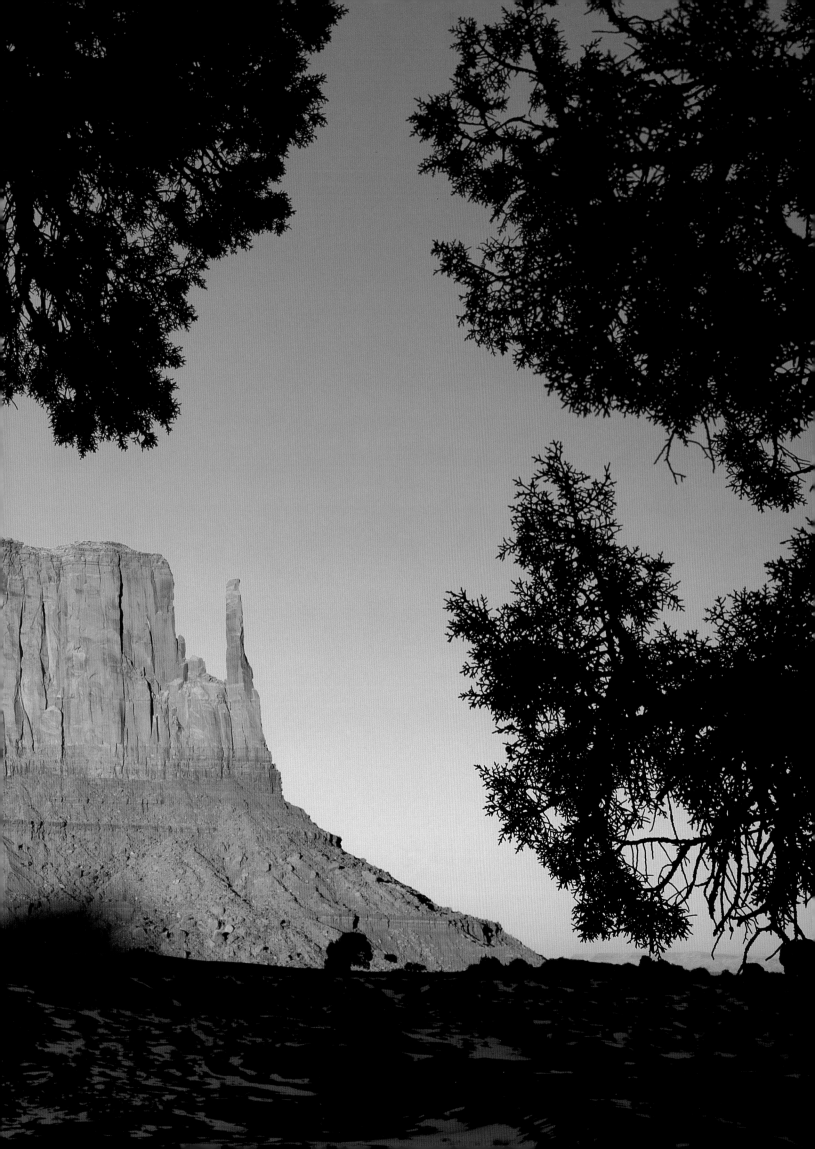

▲ Old Town, Albuquerque's original Spanish Plaza, was founded in 1706. New Mexicans call their state, *The Land of Enchantment*. A blending of rich cultural heritage and superb southwestern scenery attracts artists and writers as well as thousands of visitors.
▶ Exquisite water-sculpted chambers, scores of feet deep yet only a few feet wide, are found in some Colorado Plateau slickrock canyons. Slots, though fun to explore, are dangerous in flash floods.

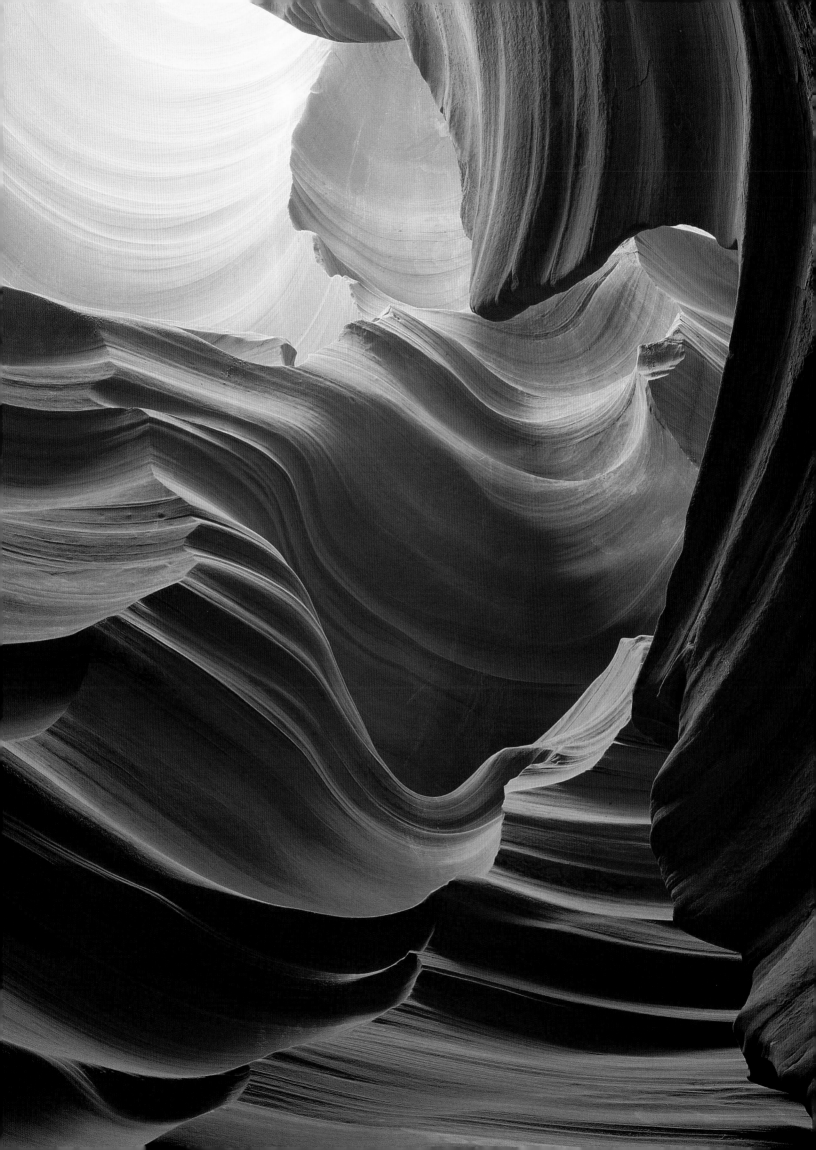

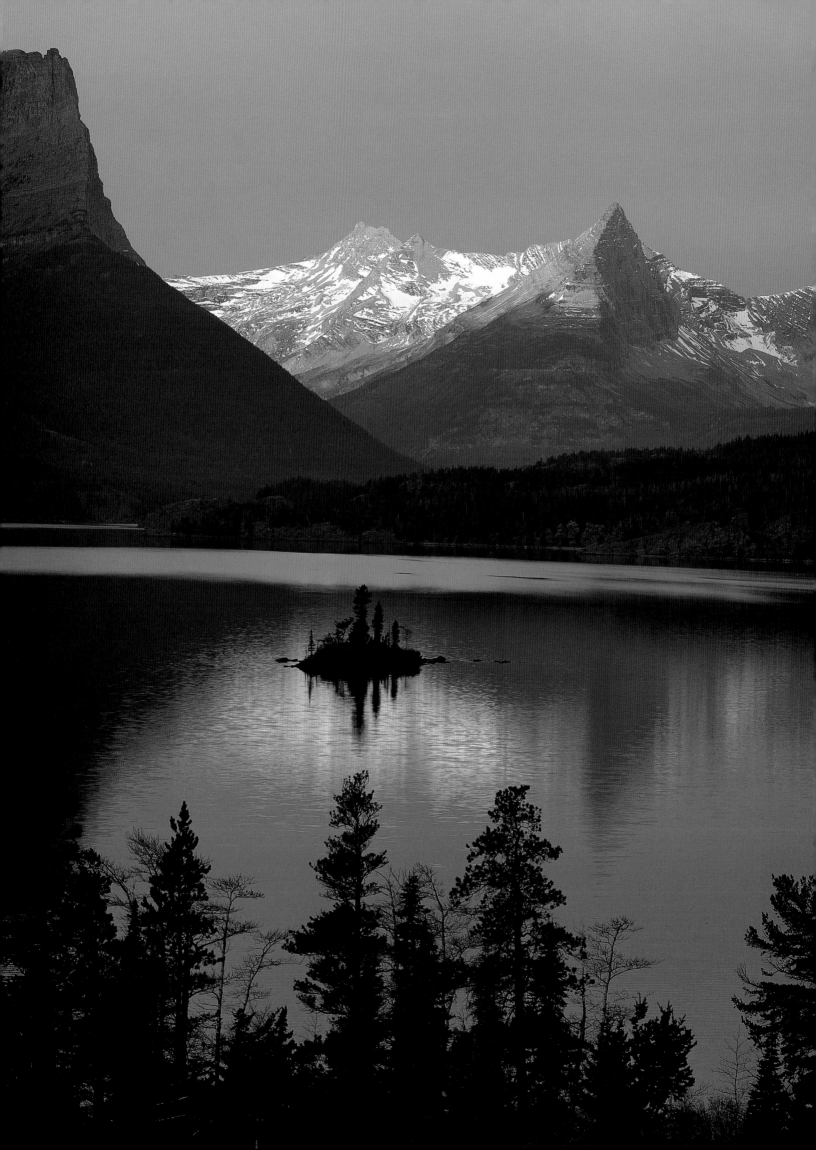

THE ROCKY
MOUNTAINS

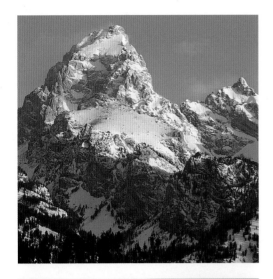

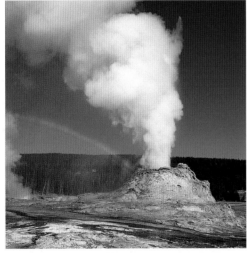

◀ *St. Mary Lake lies in Glacier National Park, part of a reserve that straddles the border between Montana and Alberta—the Waterton-Glacier International Peace Park.*
▲ ▲ *The highest point in the Teton range is the Grand Teton, towering 13,770 feet.*
▲ *The geysers, fumaroles, and hot springs of Yellowstone National Park speak of the forces of the earth. Tremendous volcanic eruptions have occurred here in the past.*

The long, slow westward roll of the prairies ends definitively as the Rocky Mountains appear on the horizon—massive, snow-capped sentinels guarding the entrance to the West. Their sheer enormity is breathtaking; in Colorado alone, fifty-two peaks rise more than fourteen thousand feet. Their impact inspires poetry; these are the "purple mountain majesties" of Katherine Lee Bates's "America the Beautiful."

The Rockies are the result of geological forces that began some sixty to seventy million years ago. Gradual uplifting caused the earth to buckle and rise, creating the mountains. The Rockies, not just a single wall of mountains, are rather an interlocking chain of mountain groups forming a rocky continental spine. The Continental Divide, the high point from which streams flow east or west, traces a meandering line along their peaks.

Before trains, planes, and automobiles, crossing those peaks was an adventure at best; at worst, a nightmare. The first non-Natives to challenge the mountains were explorers like Zebulon Pike, scouts like Kit Carson, and hardy trappers of every ilk. Beaver hats were high fashion in the early 1800s, and mountain streams were full of the busy little animals. When the beaver supply was exhausted, buffalo robes became the craze.

Then dawned the realization that those mountains were rich in precious minerals. With the discovery of gold near Denver in 1858, adventurers poured in from all over the world, starting Colorado on a cycle of boom and bust. The largest single nugget of silver, a whopping two tons, was mined at Aspen in 1879.

In 1860, a rich strike at Gold Creek started a rush to Montana, bringing in a million dollars by 1870. The population of "Last Chance Gulch," now called Helena, swelled from one hundred to twenty thousand. During the same decade, a fat vein of silver gave Butte the reputation of being the "richest hill on earth."

Early mining days were a rowdy era of saloons, dancing girls, and vigilante justice. Towns sprang to life on a rumor, as quickly becoming ghosts as their inhabitants moved on. A few, like Breckenridge and Aspen, eventually found second lives as ski resorts. Although recreational skiing did not become a commercial venture until the twentieth century, stories indicate that some miners used primitive skis made of barrel staves, and even formed ski clubs to alleviate their winter boredom.

Neither the rush for mineral wealth nor the gradual influx of farmers and ranchers that followed brought this region more than a scattering of population, by East Coast standards. Montana, the nation's fourth-largest state, has one of its smallest populations. Wyoming's population averages about five people per square mile. For a visitor from New Jersey, where population density is about one thousand per square mile, the sense of elbow room in the Rocky Mountain states may be almost as unique as the boiling pots and geysers of Yellowstone.

Yellowstone—where seething volcanic magma, deep underground, generates some ten thousand geysers, pools, mud pots, and vents—is only one example of how this region brings its inhabitants face-to-face with earth's essence. This region is, after all, defined by its powerful geography.

Anyone who has breathed the mountain air, seen the alpine meadows, fished the cold mountain streams, knows: the real wealth of the Rockies is not minerals. It is in the beauty of the vast, unspoiled wildness. Teddy Roosevelt called it, "Scenery to bankrupt the English language."

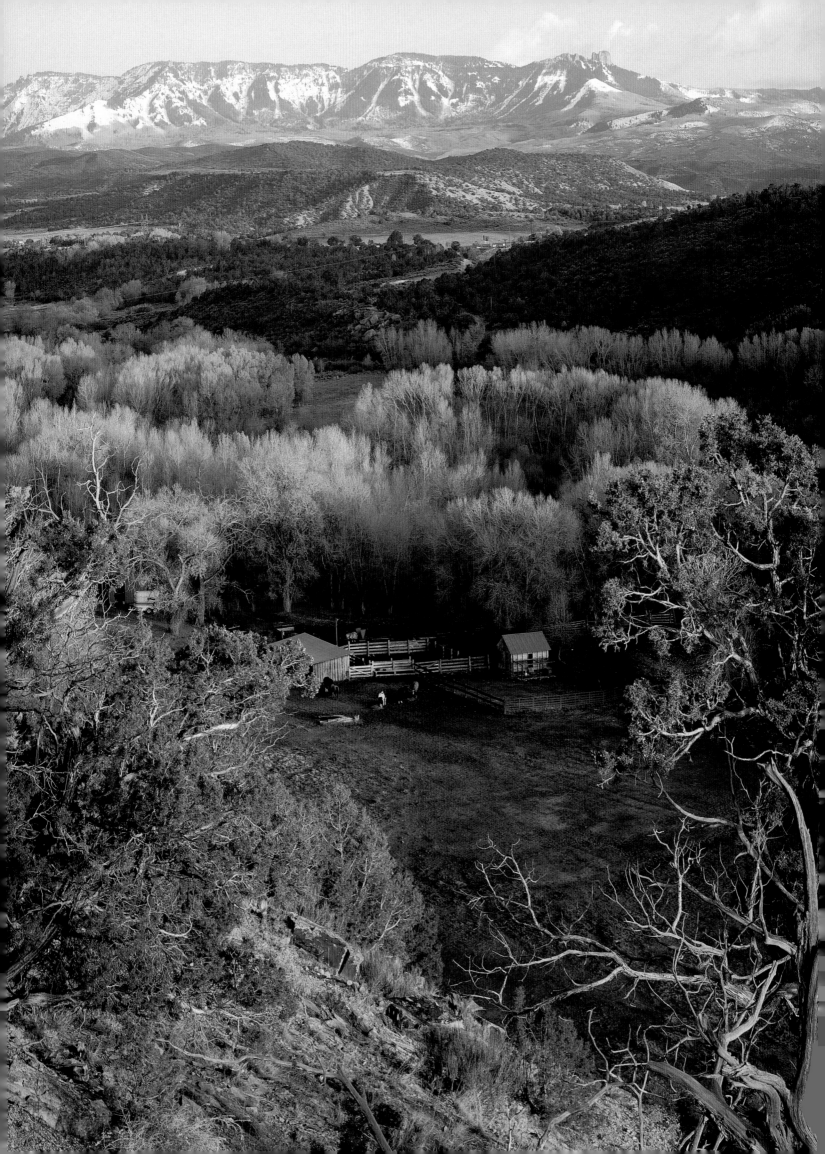

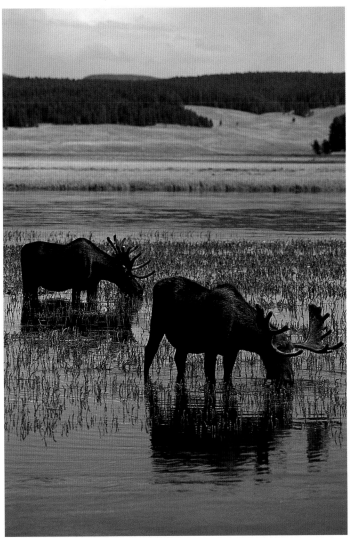

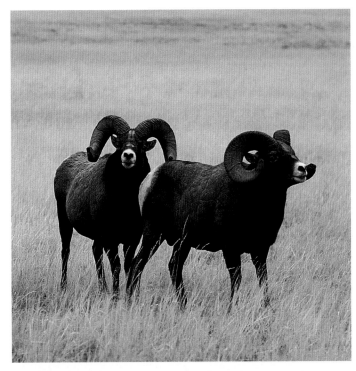

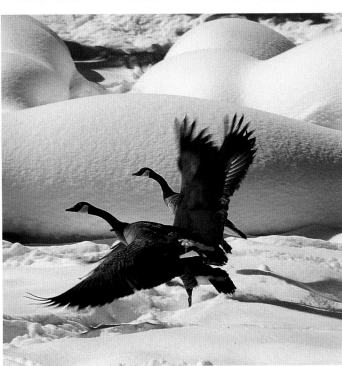

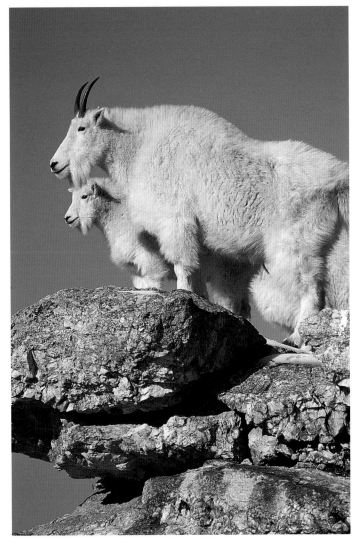

◄ Grasslands of the valleys and basins of Colorado's Rocky Mountains provide space for cattle and sheep ranching.
▲ *Clockwise:* The Rockies host abundant wildlife including moose, bighorn sheep, mountain goats, and Canada geese.
►► Mount Moran punctuates the sky in Wyoming's Grand Teton National Park, established in 1929.

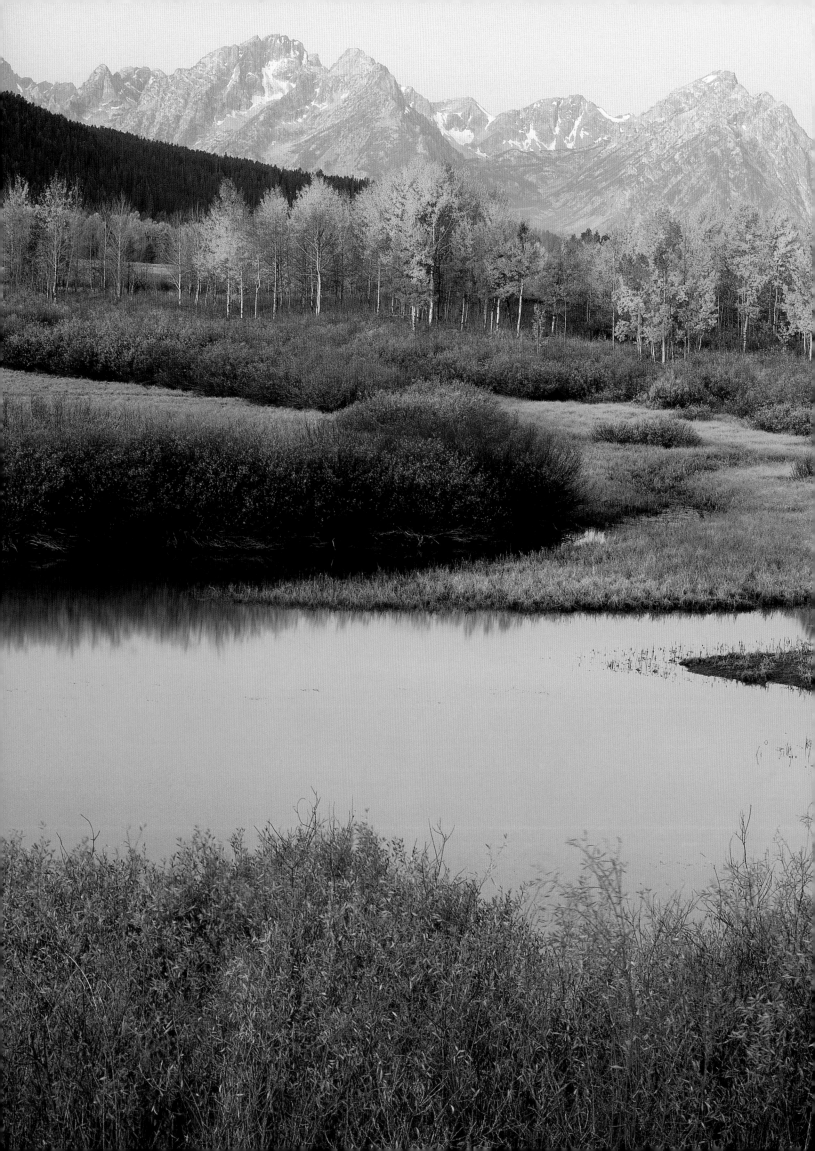

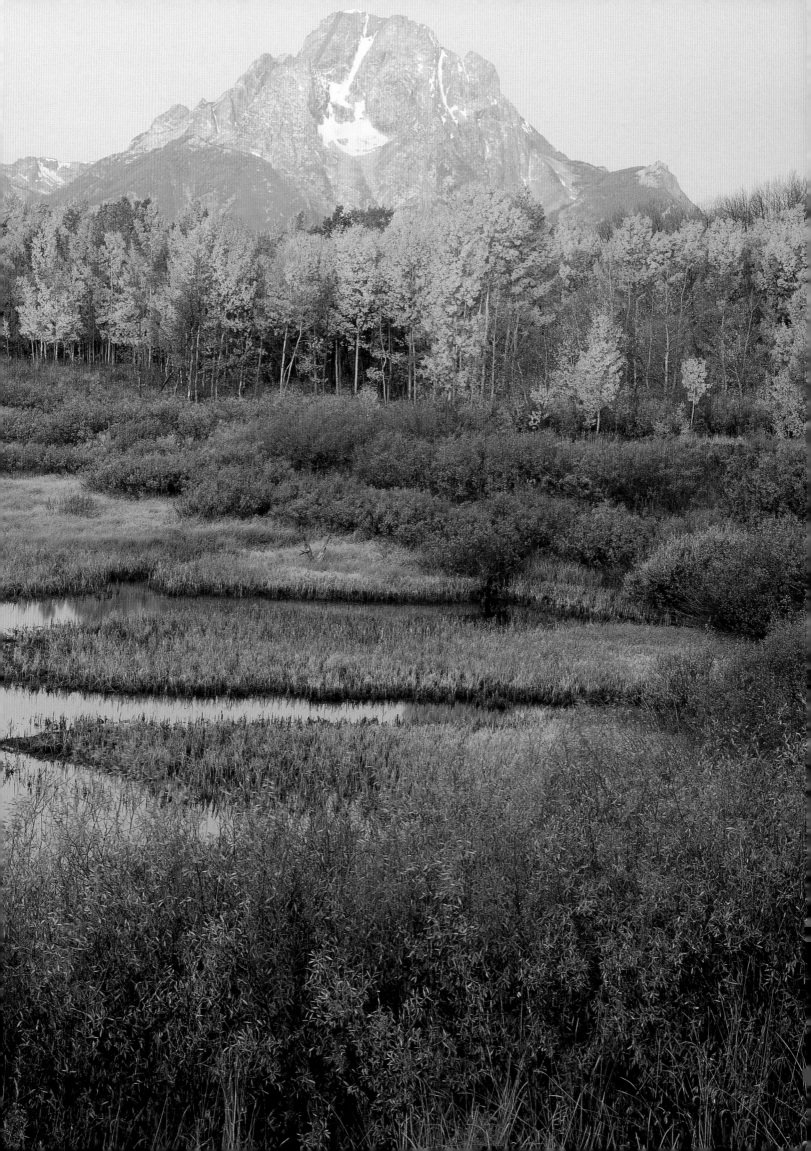

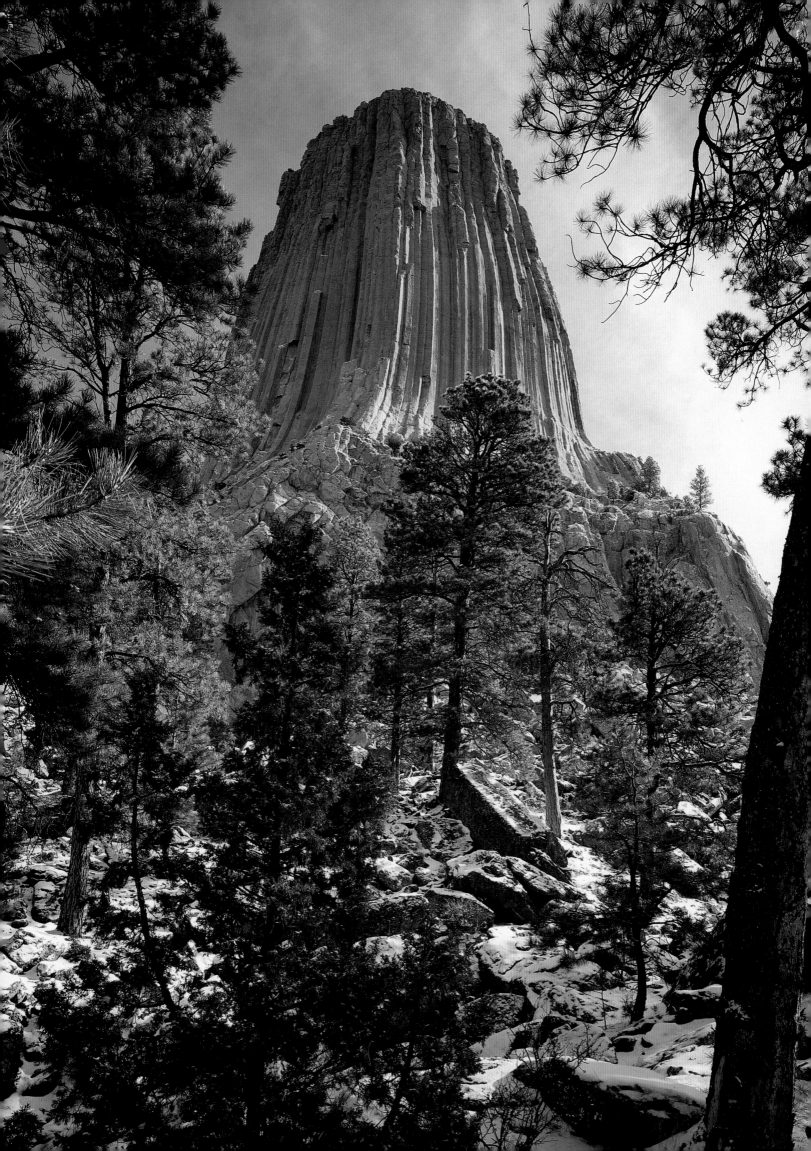

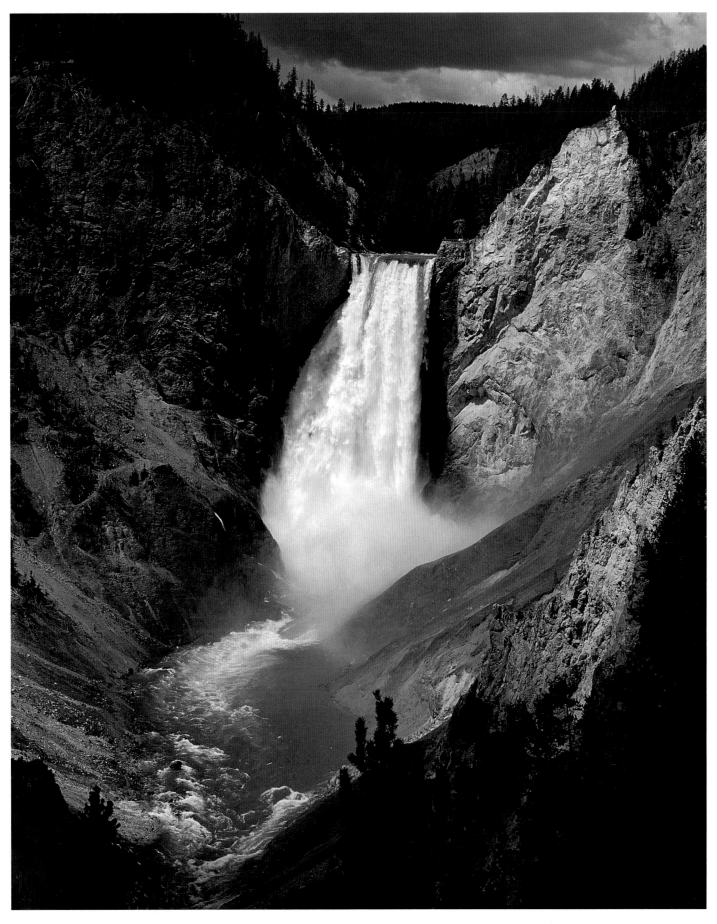

◄ Eastern Wyoming's Devils Tower, established as a national monument in 1906, reaches 865 feet into the sky.
▲ The Lower Falls of Yellowstone River plunge 308 feet into the Grand Canyon of the Yellowstone.

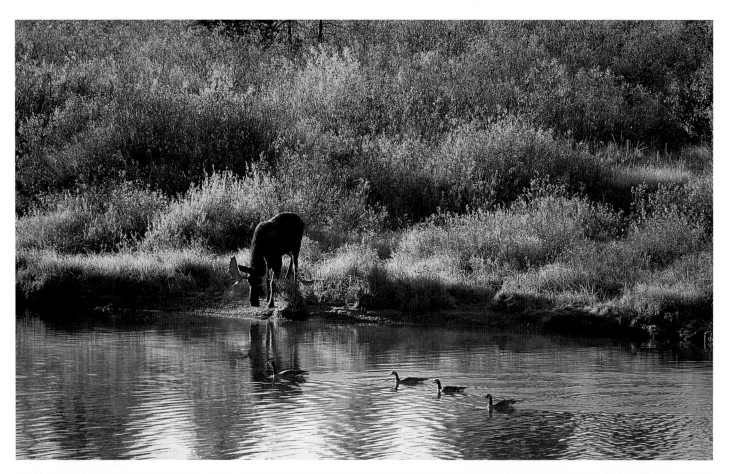

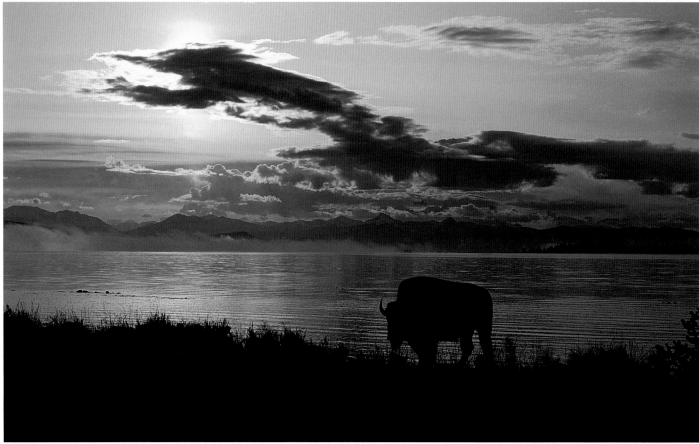

▲▲ A bull moose and Canada geese coexist at Oxbow Bend of the Snake River in Wyoming's Grand Teton National Park.
▲ A lone bison grazes along the shore of Yellowstone Lake. An estimated sixty million bison once inhabited North America.
► Sievers Mountain and Maroon Lake in White River National Forest show some of the scenic variety found in Colorado.

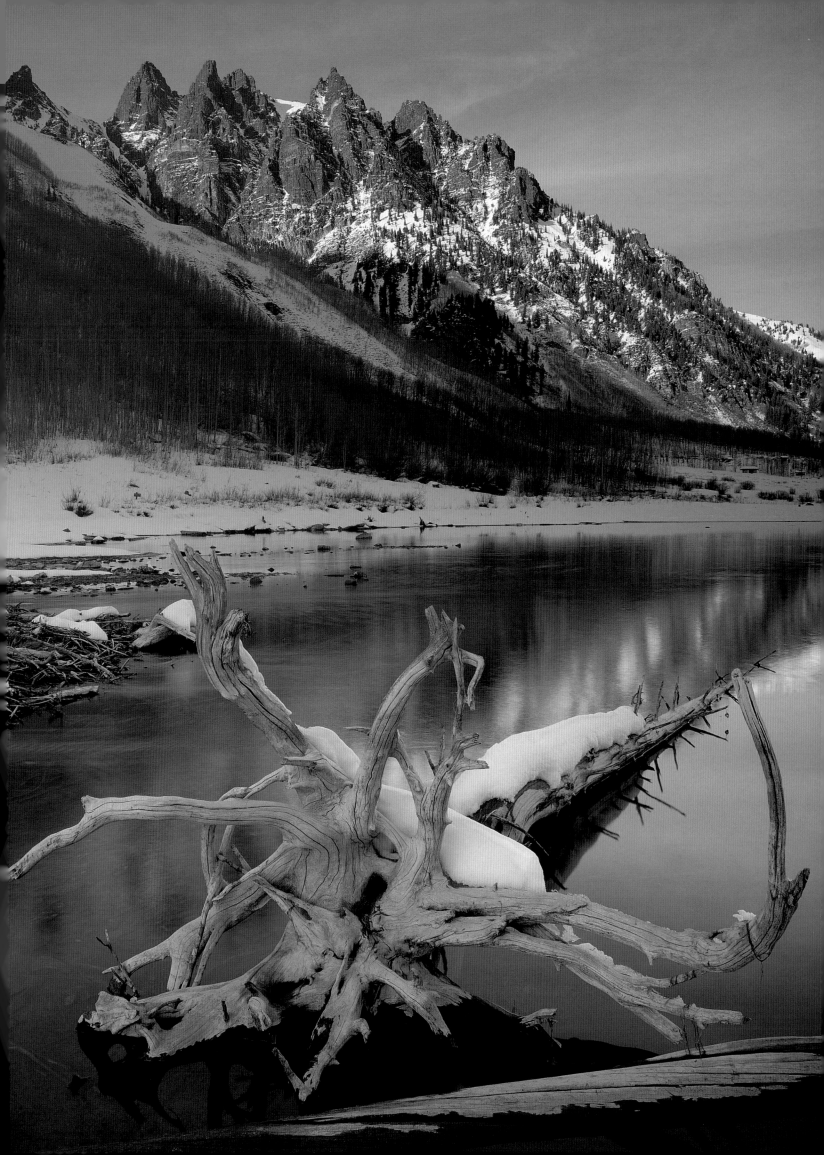

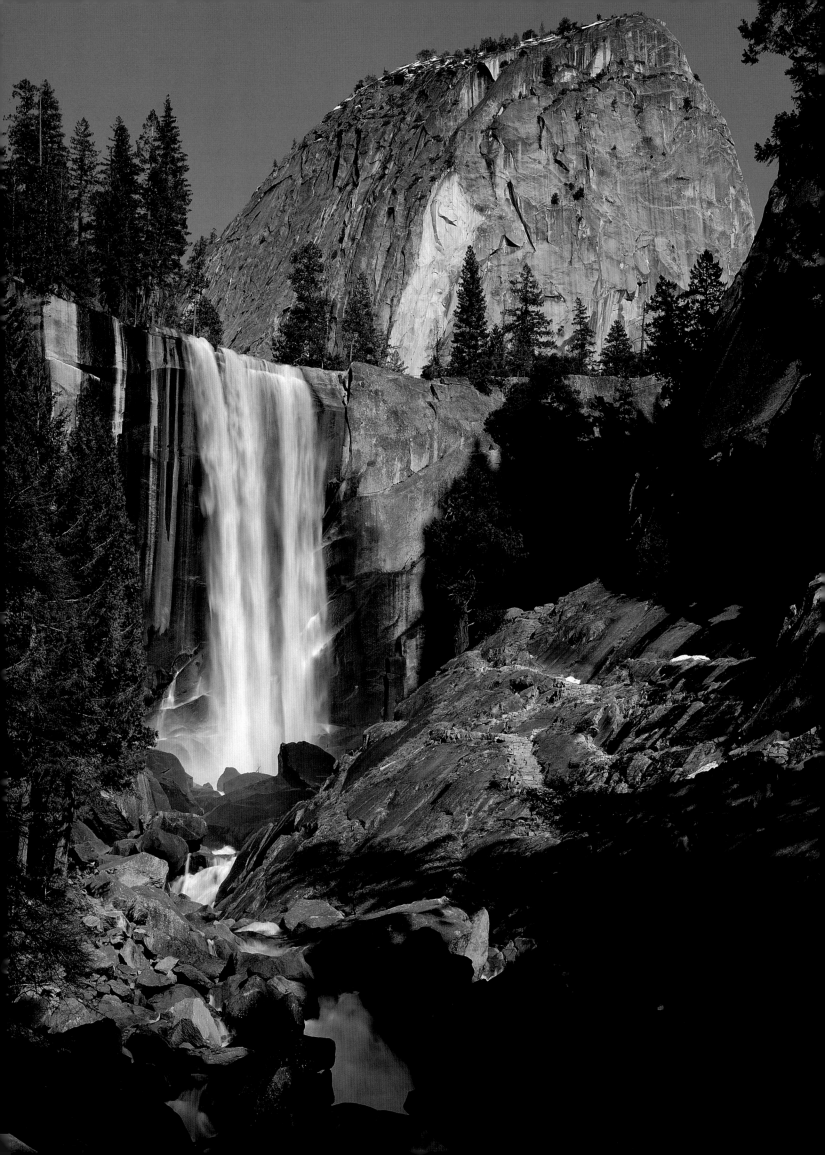

THE
FAR WEST

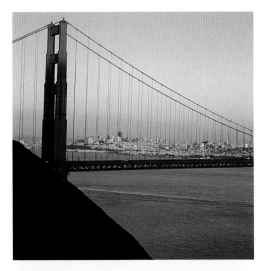

◀ *The Merced River drops 317 feet over Vernal Fall, in Yosemite National Park, California. The Liberty Cap looms beyond.*
▲ ▲ *Spanning one of the largest harbors in the world, San Francisco's 8,981-foot-long Golden Gate Bridge, completed in 1937, has become one of the icons of America.*
▲ *Piedras Blancas Light, which is visible from Highway 1, was completed in 1875.*

". . . turn your face to the great West, and there build up a home and fortune," Horace Greeley advised in a mid-nineteenth-century *New York Tribune* editorial. Go west they did—prospectors chasing the promise of gold and silver in the Sierra Nevada, and families challenging the mountains to claim rich farmland in the valleys beyond.

Easterners often fail to realize how big this region is—and how much diversity it contains. Transposed to the Atlantic Coast, California would reach from Cape Cod to Savannah. California and Nevada would blanket more than a dozen states. California's coastline extends 840 miles from cool redwood forests in the north to the sunny Mexican border. Eastward, after rolling past the coastal mountains, this region includes rich farmland, climbs over the beautiful Sierra Nevada, christened by John Muir as the "Range of Light," crosses desert land in the mountains' shadow, and rolls across the arid Great Basin.

Spain laid early claim to the California coast; Route 101 was forged in 1769 as El Camino Real. That Royal Road linked the missions established to make Catholics and farmers of the local Indians. The effort faltered, but Spain's legacy still rings in the names of mountains, streams, and cities.

The discovery of gold at Sutter's Mill in 1848 opened a lively chapter in California history. "Forty-niners" poured in from all directions. A few got rich; most merely subsisted. Their story is in the towns they settled, and quickly deserted—Rough and Ready, Fiddletown, Iowa City, Fair Play, Hangtown.

A decade later, Nevada took the spotlight when silver was discovered in the Comstock Lode. Virginia City became the new mining metropolis, boasting fabulous wealth, 110 saloons, and the only elevator between Chicago and San Francisco. Prosperity propelled the Silver State into the Union in 1864, just in time to cast the final vote for slavery's abolition.

As prospectors panned for gold, more patient immigrants worked the rich soil in California's broad Central Valley, where a temperate climate promised fortunes in fruits and vegetables. Today, abundance of every kind of produce, plus beef and dairy cattle, makes agriculture California's top industry. Napa Valley produces splendid wines, and with irrigation, even the Mojave Desert yields watermelons and almonds.

San Francisco, set on a fine natural bay, grew by leaps and bounds during the late 1800s. By 1904, it had a population of four hundred thousand and was called simply "the City." Then came the earthquake and fire of 1906. The city rebuilt. The earth shook again in 1991, and the spirited city once more rebuilt.

If San Francisco is vintage California, Los Angeles is the city of today. Spilling over the hills and valleys, laced with freeways, it has made the world familiar with places like Hollywood and Disneyland.

Across the mountains are two more cities known for their neon and glitz, Reno and Las Vegas. Beyond is the true Nevada—vast, empty stretches of rangeland; huge, working ranches where cowboys still do serious riding; and authentic small towns that hark back to another generation.

The most venerable living things in the Far West hark back further still, and have nothing to do with roads or cities. In this region live the largest, tallest, and oldest trees in the world. They stand quietly—those giant sequoias, soaring redwoods, and ancient bristlecone pines—waiting, like the mountains, ready to remind anyone who walks among them that the land came first, and shaped human endeavors.

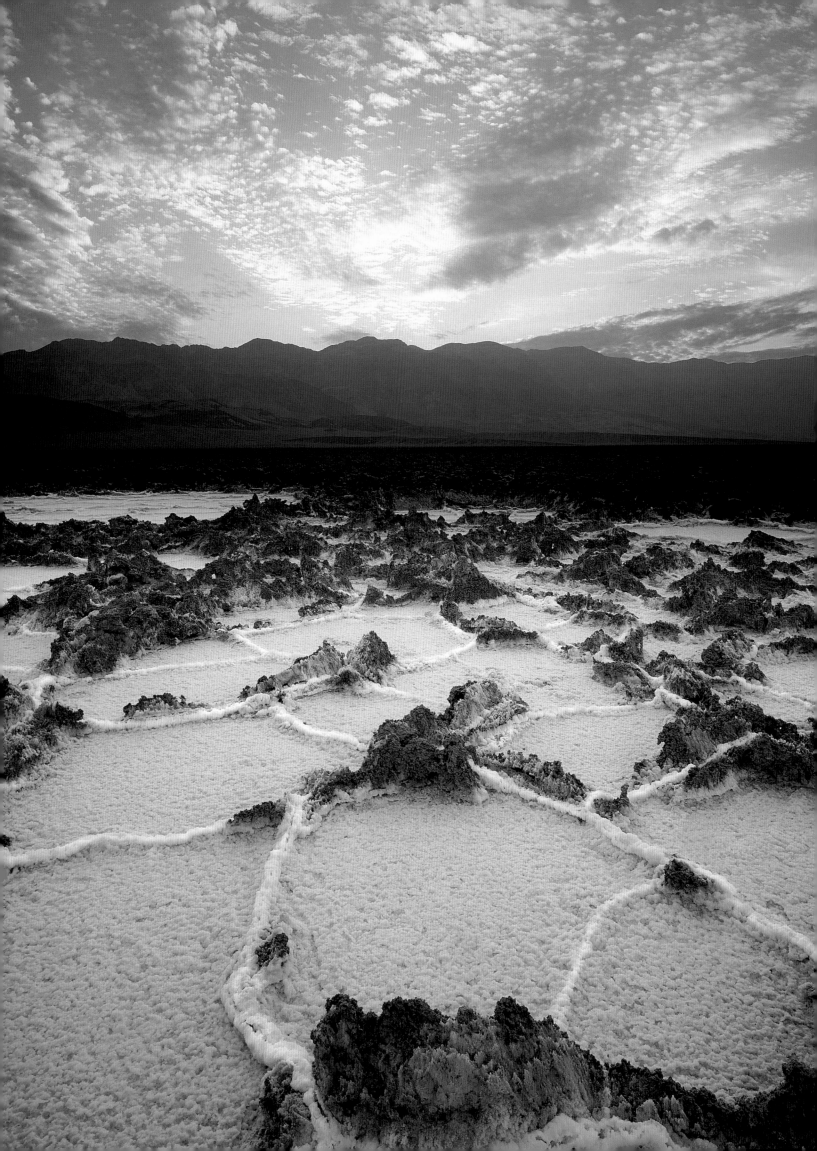

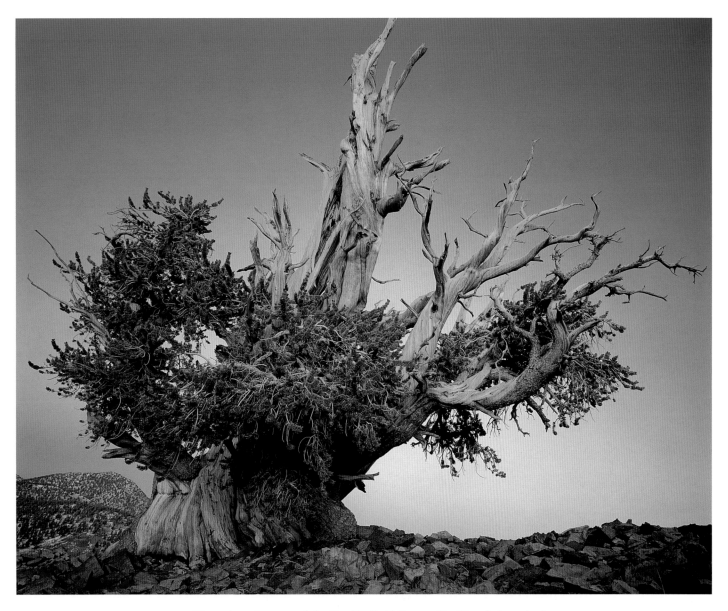

◄ Near the salt pans of the Devils Golf Course lies North America's lowest elevation, at 282 feet below sea level. Death Valley National Park, with over 3.3 million acres, is the Lower 48's largest park.
▲ The sculpted form of an ancient bristlecone pine tenaciously clings to a windswept ridge of the White Mountains, in California's Inyo National Forest. The earth's oldest living trees exist in one of its harshest environments. Some have lived forty-six hundred years.

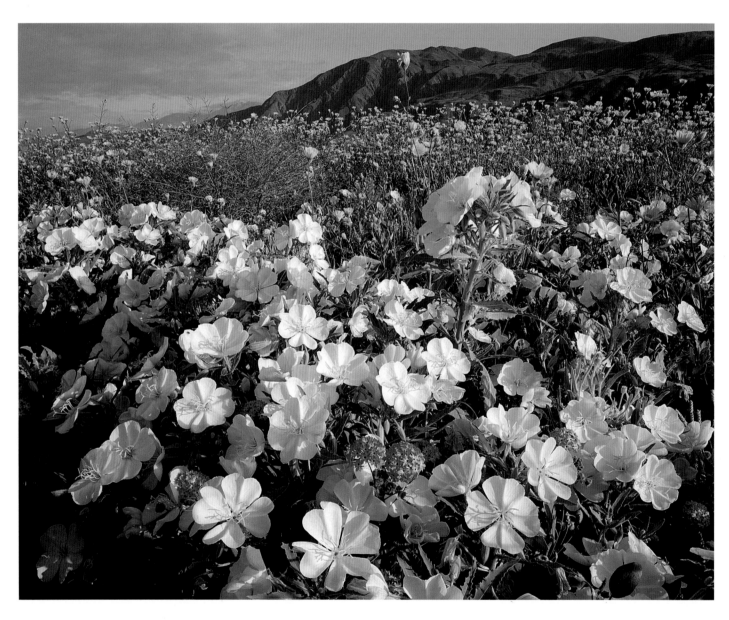

▲ Anza-Borrego Desert State Park surrounds a rich variety of
blooms: desert sunflower, dune evening primrose, and sand verbena.
► Coast redwoods tower above a road in Jedediah Smith Redwoods
State Park and Redwoods National Park. The tallest living things in
the world, coast redwoods may grow to three hundred seventy feet.
► ► The Santa Cruz Light is a "memorial lighthouse" built in 1967.
The first lighthouse at Santa Cruz was illuminated January 1, 1870.

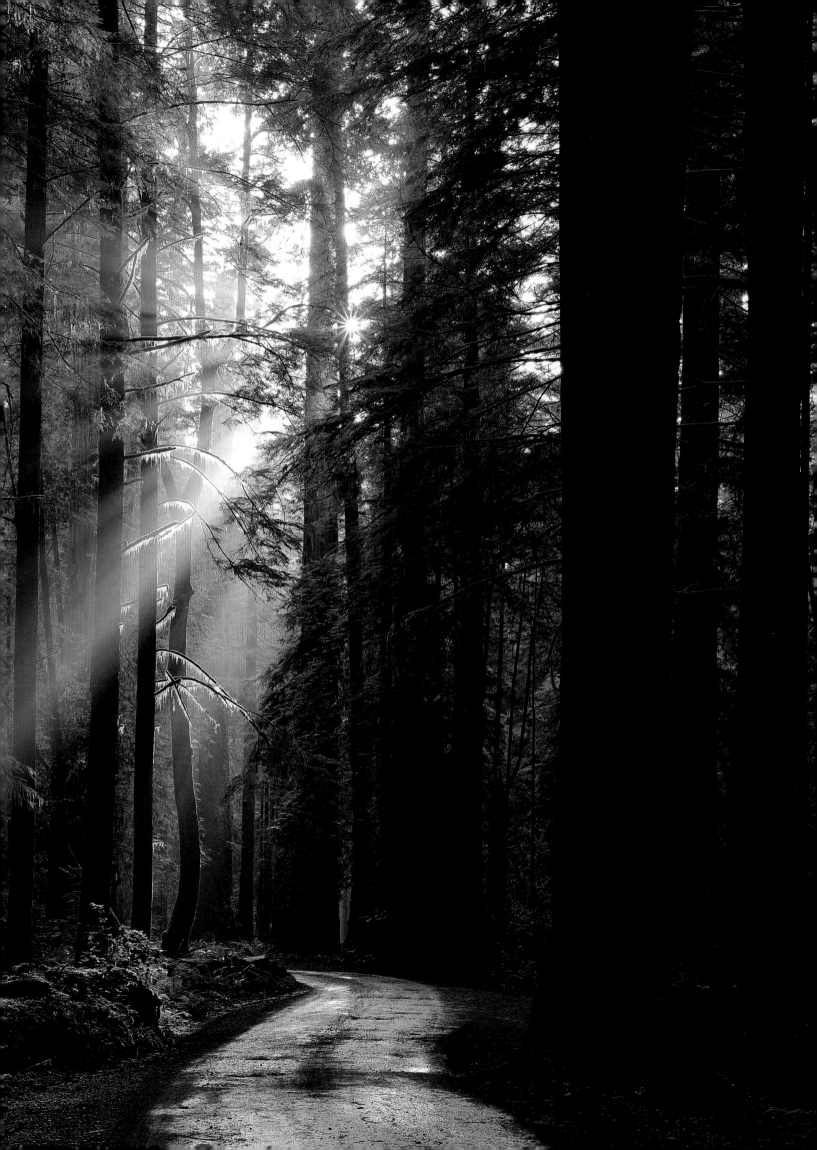

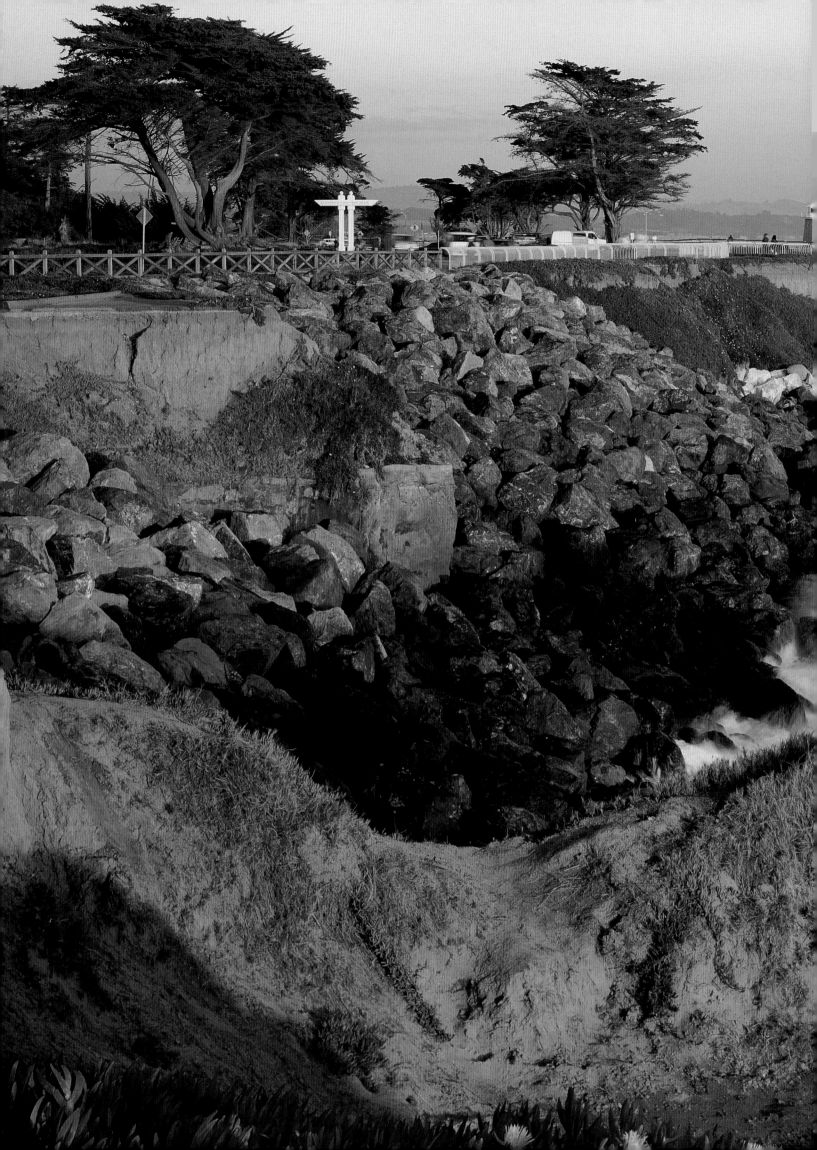

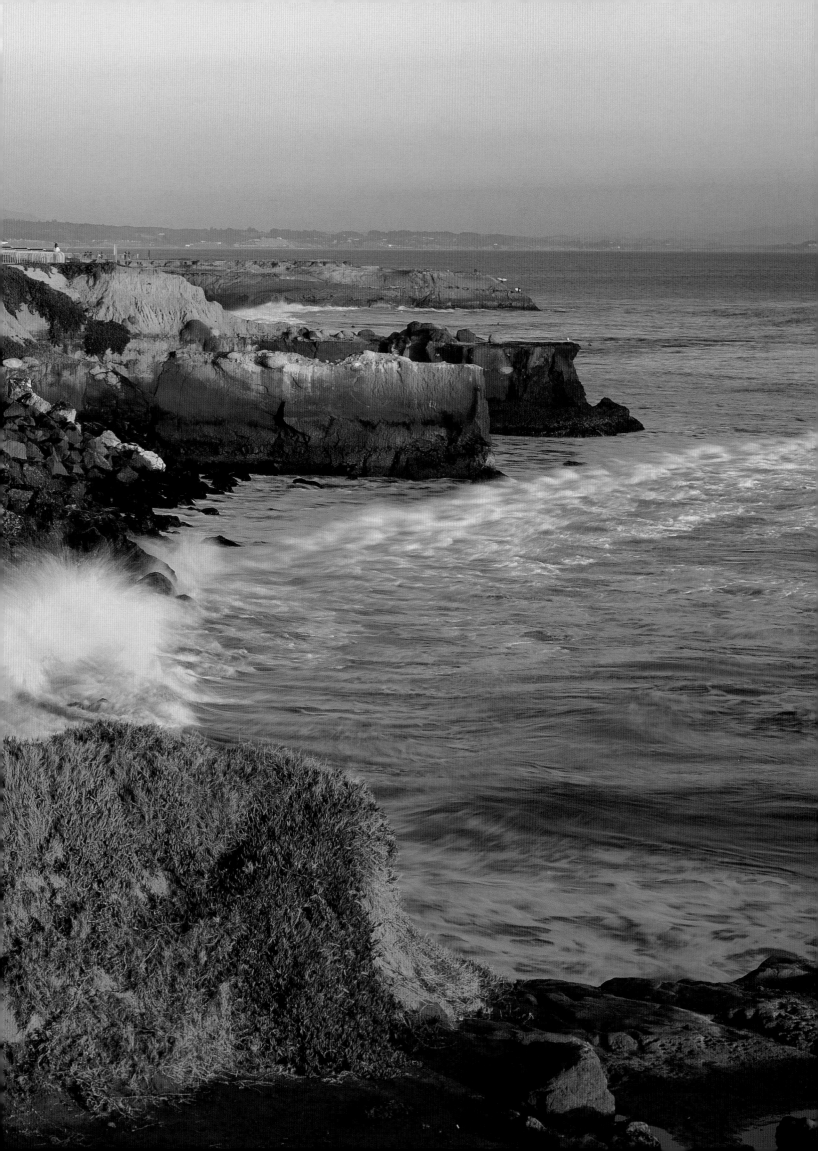

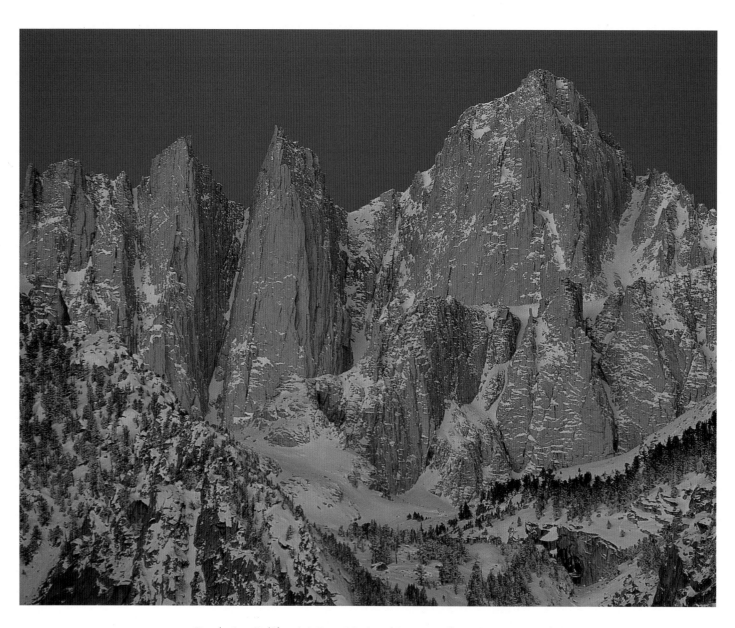

▲ Bordering California's Inyo National Forest and Sequoia National Park, 14,494-foot Mount Whitney is the Lower 48's loftiest peak.
► Rime ice coats Jeffrey pines growing along the Lee Vining Creek in the Inyo National Forest. Diverted for decades to water a thirsty Los Angeles, today the creek gurgles into Mono Lake, helping to preserve a fragile ecosystem that supports millions of tiny brine shrimp and the largest inland colony of nesting California gulls.

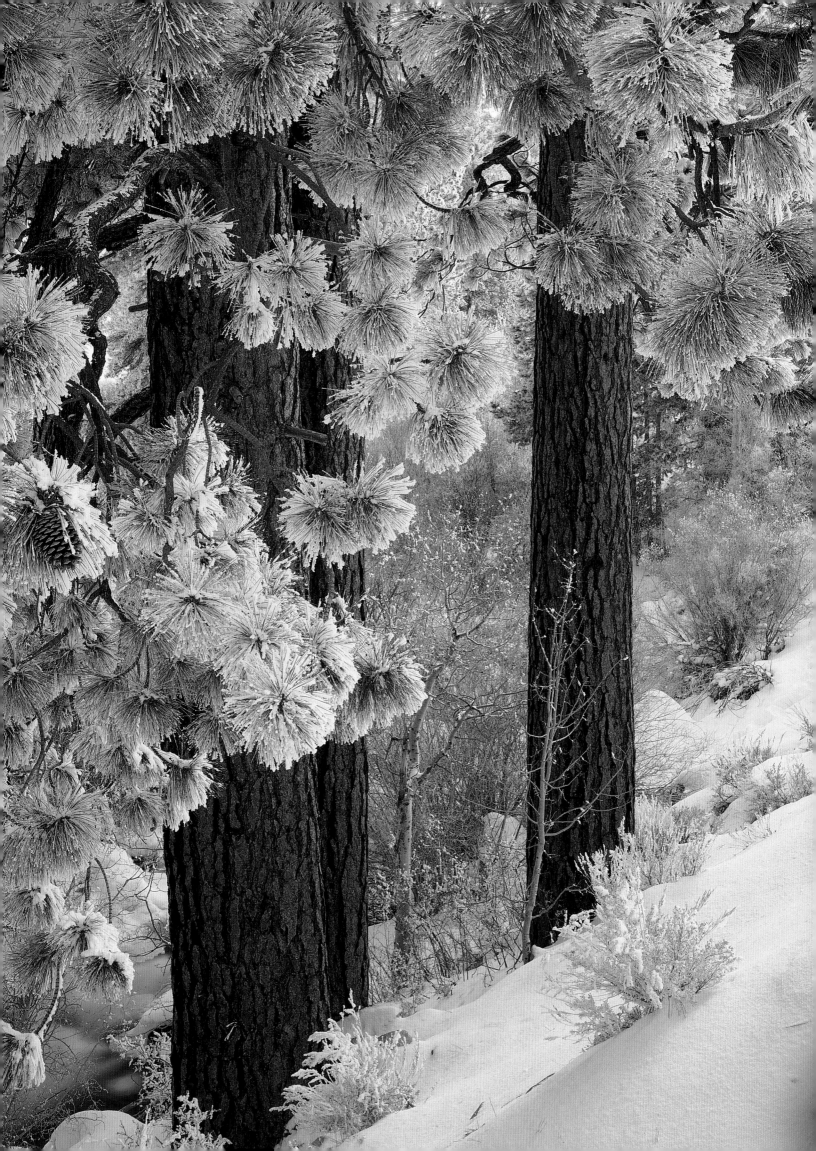

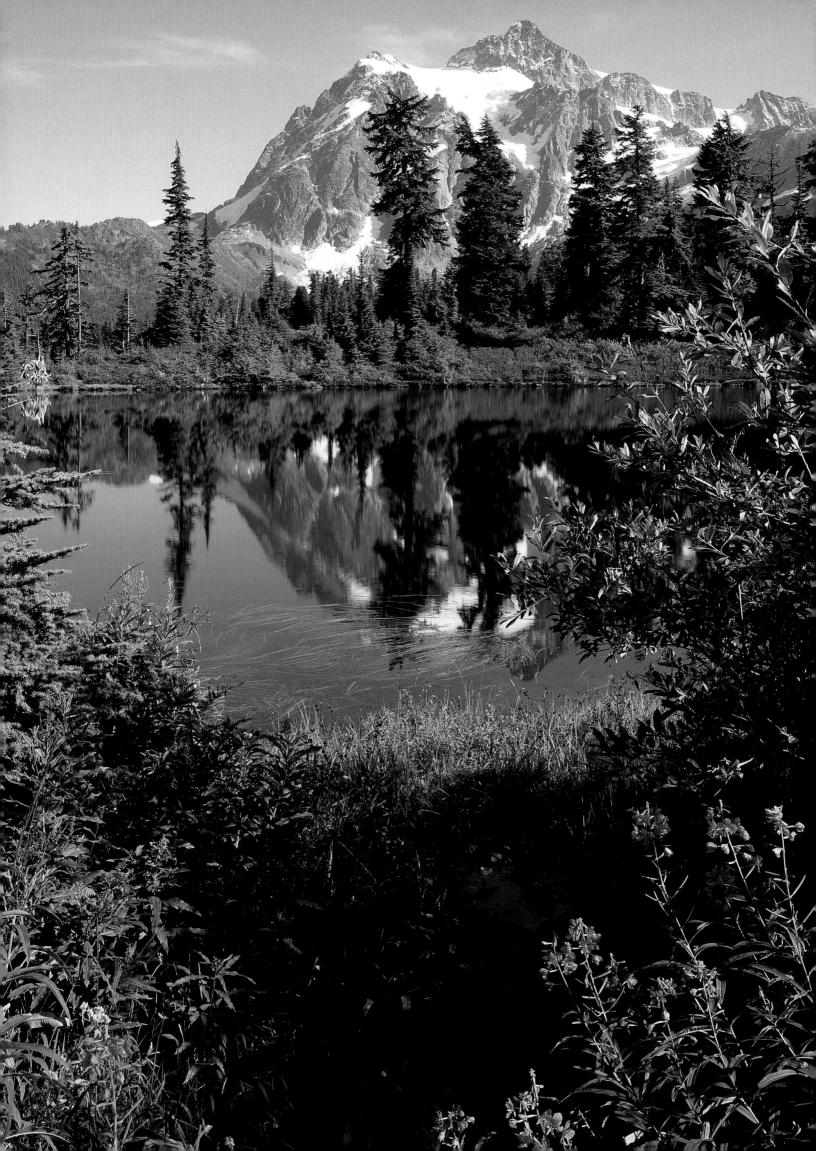

THE
NORTHWEST

In 1846, at the end of the Oregon Trail, Thomas Bonney wrote in his diary, "We can say we have found the most splendid and beautiful country, with rich prairie land and timber adjoining, together with good water and springs. . . ." Bonney was one of thousands who endured a bruising, two-thousand-mile trip by covered wagon for the promise of a new life in the Pacific Northwest. They called it the "New Eden."

Each spring in the mid-1800s, the long wagon trains from Independence, Missouri, snaked across the prairies and over the Rockies, leaving a trail of possessions and grave sites in their wake. Oregon Country began in what is now Idaho, but the wagons pushed on, crisscrossing the Snake River and rafting through the windswept, wickedly beautiful Columbia River Gorge. They were headed for the fertile, well-watered valleys beyond the Cascades.

A Native American legend explains the region's geography with elegance. Long ago, it seems, Ocean scooped dirt from Puget Sound and built a wall of mountains to keep his children, Rain and Cloud, close to home. As a result, the land west of the Cascades is lush and green, but the skies are often cloudy; east of the mountains the sun shines, but the land is thirsty.

Northwest population has concentrated west of the Cascades. Idaho residents will tell you they are glad; it gives them more room to enjoy the "Light on the Mountains," which is what *E-dah-ho* means. The Northwest's two major cities were situated for water access. Seattle weaves around Puget Sound inlets; Portland bridges the Willamette River, just before it reaches the Columbia. Seattle, dubbed "the Emerald City" for its lush vegetation, is a sophisticated metropolis with an easy, relaxed atmosphere. Clean, friendly Portland is a tribute to good planning and strong civic pride.

Snow-capped Cascade peaks grace the skylines of both cities. According to Klikitat Indian legend, those volcanic mountains were once handsome braves, in love with the same beautiful maiden. They fought so furiously that rocks and fire flew across the Columbia River and the very earth shook. To stop the fuss, the gods finally changed them into Mounts Rainier and Hood. The maiden, who became Mount St. Helens, had the last word; she blew her top in 1980.

The Northwest's Native Americans, among the continent's most prosperous, enjoyed abundant timber, fish, and game. They lived in sturdy longhouses, built stout canoes, carved handsome ceremonial masks, and held elaborate potlatches. Living as one with the land, they apologized to the spirit of each fat salmon they took from its rivers. That richness is not lost on present-day occupants, either. Leaders in environmental concerns, they have an unabashed love of the out-of-doors. Camping in the forests of Olympic National Park, biking in the San Juan Islands, skiing on Mount Hood, rafting on the Clearwater River, walking along the cliff-lined Oregon Coast—even for city dwellers, all these pleasures are within easy reach. Hiking, climbing, hang gliding, skiing, sail boarding, white-water rafting—Northwesterners do it all.

◄ Mount Shuksan, 9,125 feet high, reigns over North Cascades National Park. The North Cascades are called America's Alps. ▲▲ Ilwaco Harbor lies near the mouth of the Columbia River on the Washington side. ▲ Founded in 1825 as a part of the empire of Hudson's Bay Company, Fort Vancouver was named for Northwest explorer Captain George Vancouver. The fort lies within the city borders of Vancouver, Washington.

Lewis and Clark, who forged to the mouth of the Columbia in 1806 at Thomas Jefferson's request, grumbled in their journals about the rain. But anyone who lives in the Northwest—or has, and longs to return—will tell you that gray days and drizzle are a small price to pay for those glorious, clear-skied days, when mountains rise sharp and white on the horizon. A small price, too, for easy access to forest trails, splendid slopes, and quiet beaches, all in an area where people take time to enjoy them.

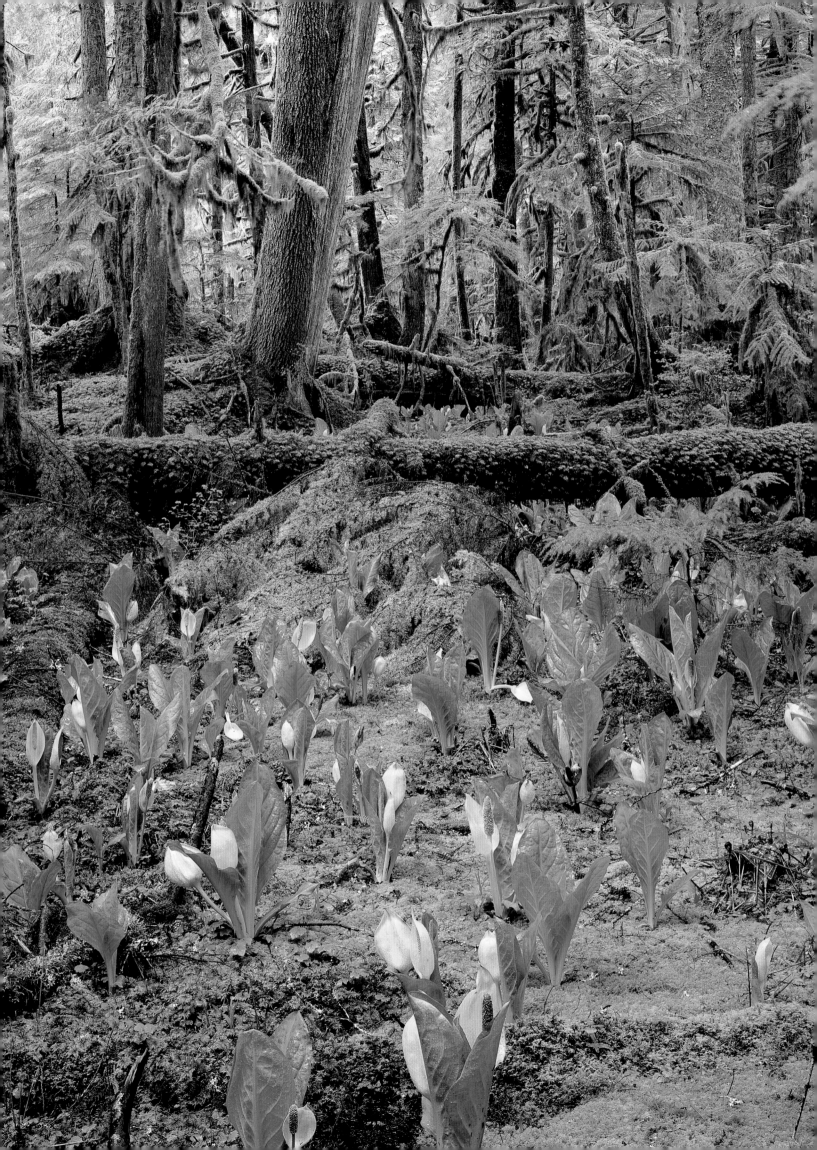

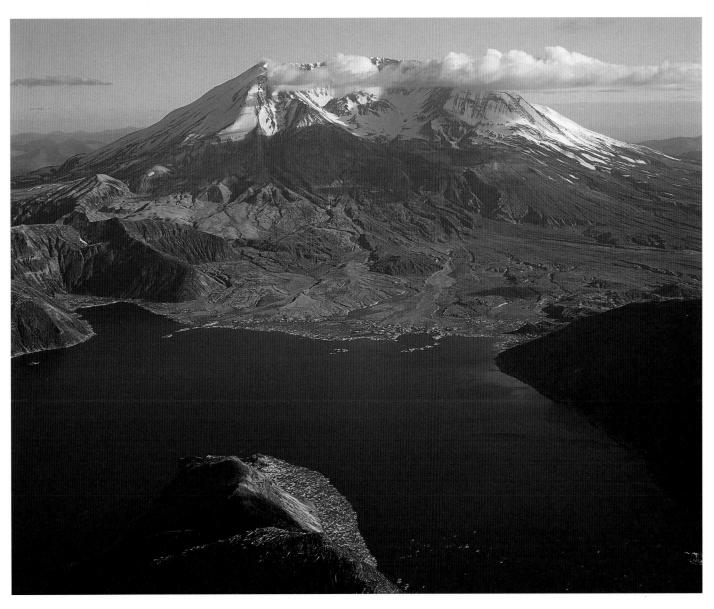

◄ Skunk cabbage decorates the floor of the Carbon River Rainforest in Mount Rainier National Park. A relatively young volcano of the Cascade Range, Mount Rainier is only about one million years old.
▲ The May 18, 1980, eruption of Mount St. Helens reduced its elevation from 9,677 feet to 8,366 feet. On that fateful day, a fiery billow of smoke and ash rose more than sixty thousand feet. The mountain, as well as the surrounding land, was left devastated.

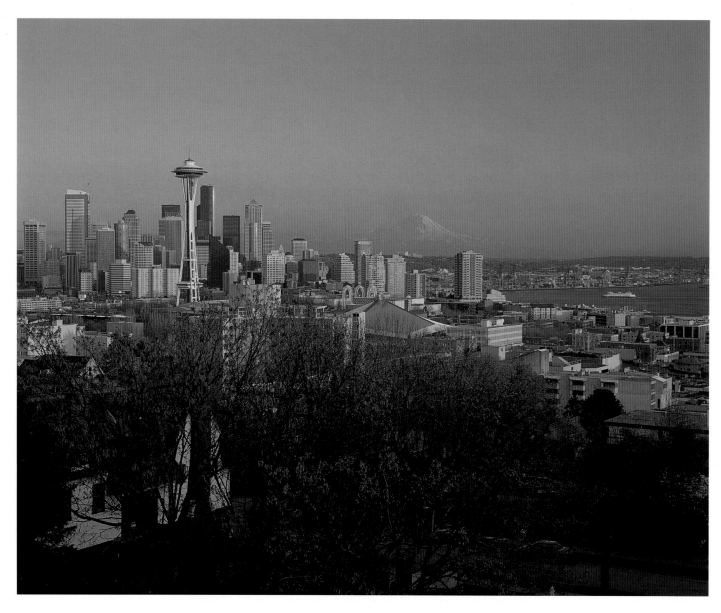

▲ Beyond the "Emerald City" of Seattle looms the magnificent summit of Mount Rainier. The largest city in the Pacific Northwest, Seattle is a major deep-water port utilized for shipping throughout the Pacific Rim and is home to a number of well-known corporations.
▶ Steptoe Butte State Park in eastern Washington rises above rolling wheat fields. Dryland wheat flourishes with ten to twelve inches of annual precipitation and yields thirty to forty bushels per acre.

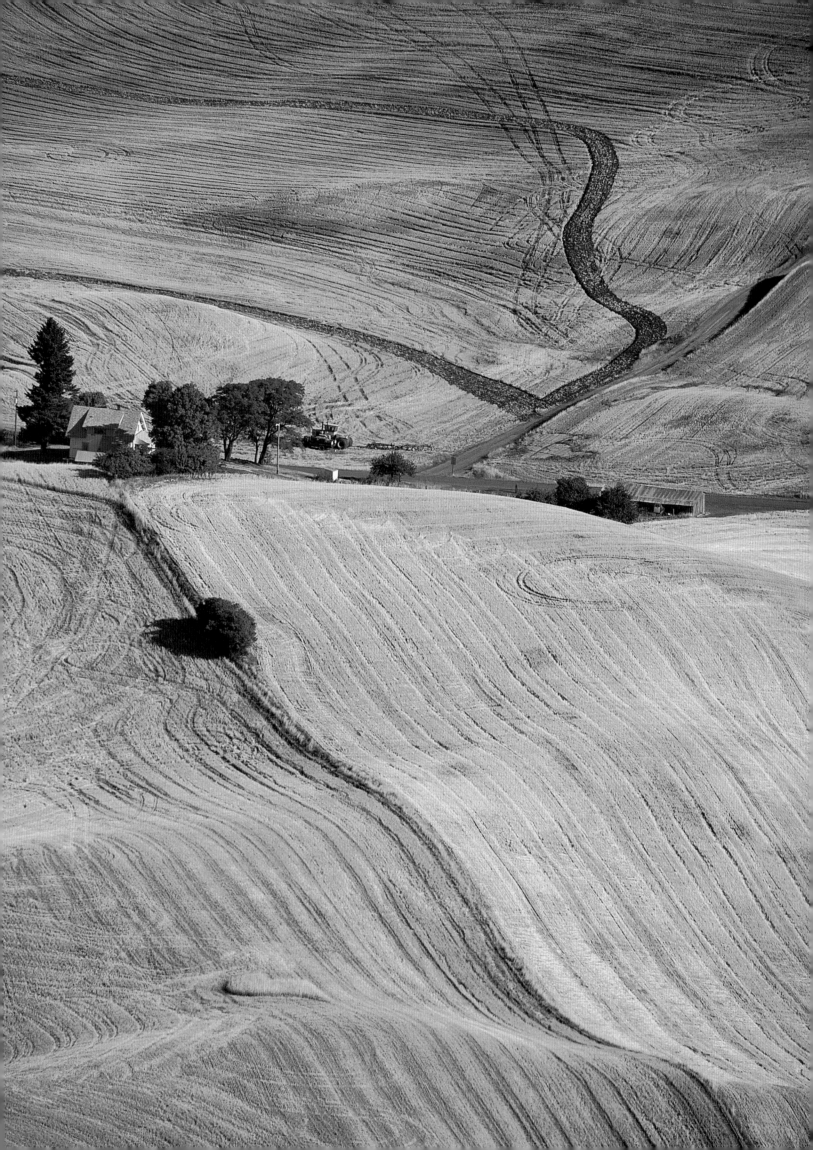

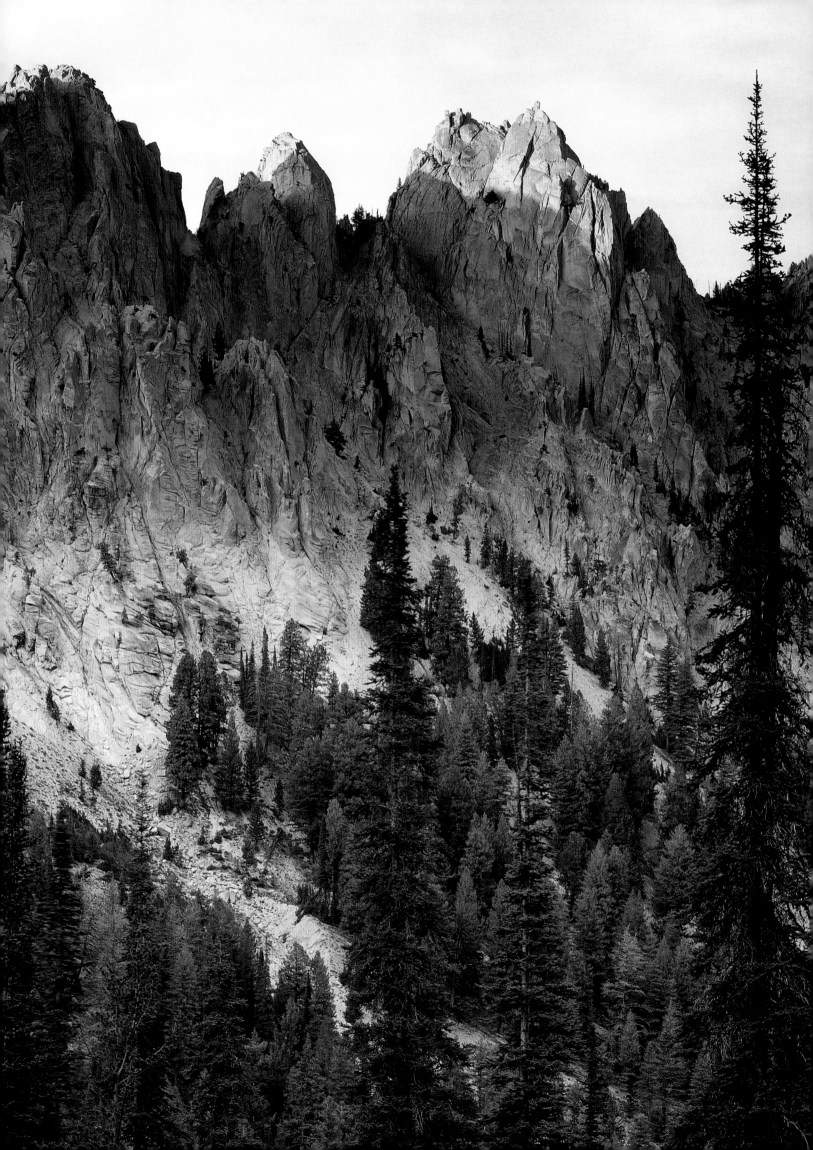

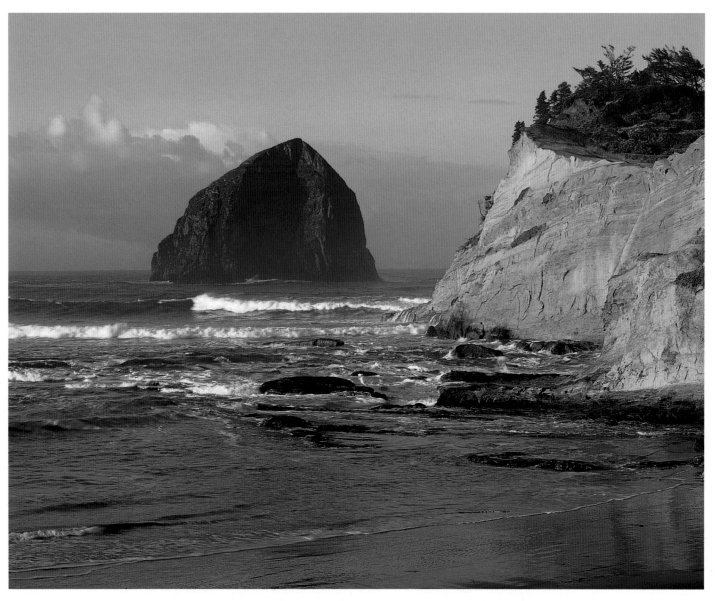

◄ Peaks of the Sawtooth Range slice the sky north of Alpine Lake in the Sawtooth Wilderness of Idaho's Sawtooth National Forest. Forty-two peaks in the range rise higher than ten thousand feet.
▲ The sandstone cliffs of Cape Kiwanda, on Oregon's coast, are partially protected from the raging surf by 327-foot Haystack Rock.
► ► Crown Point's Vista House rises 725 feet above the Columbia River. Made of stone from Italy, Vista House was completed in 1916.

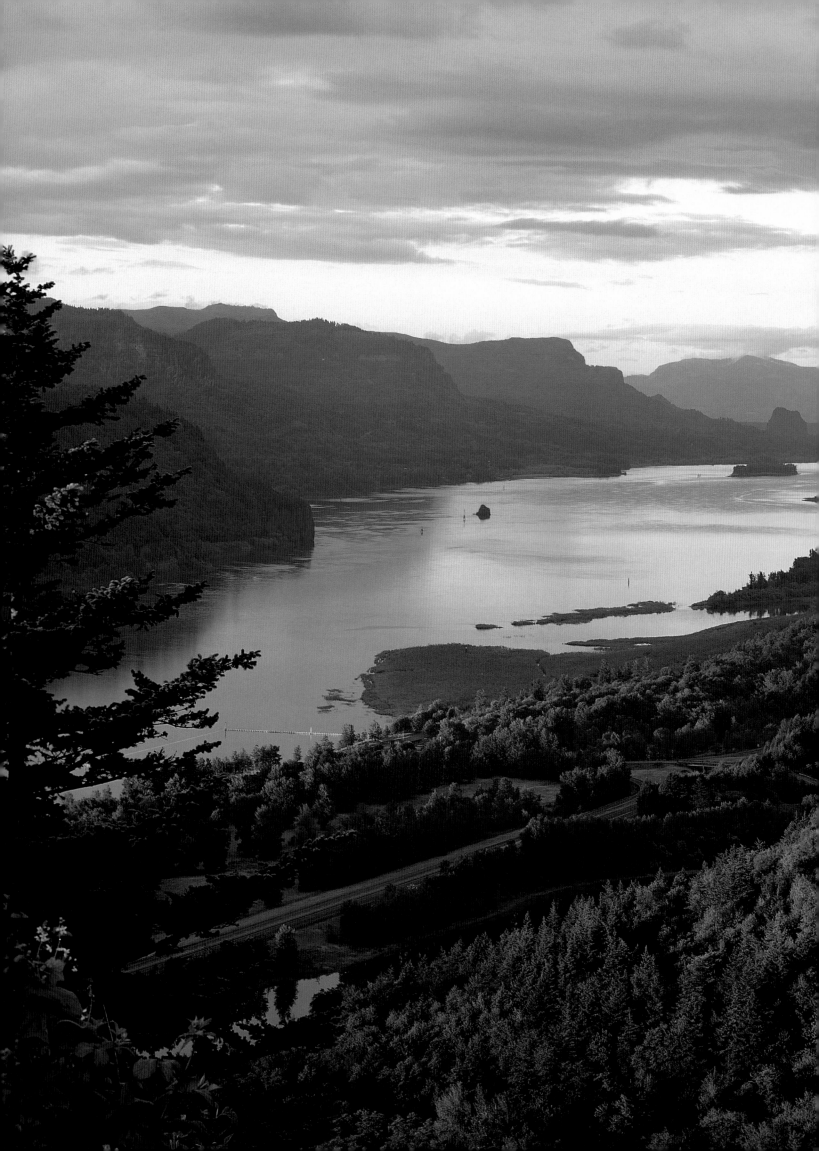

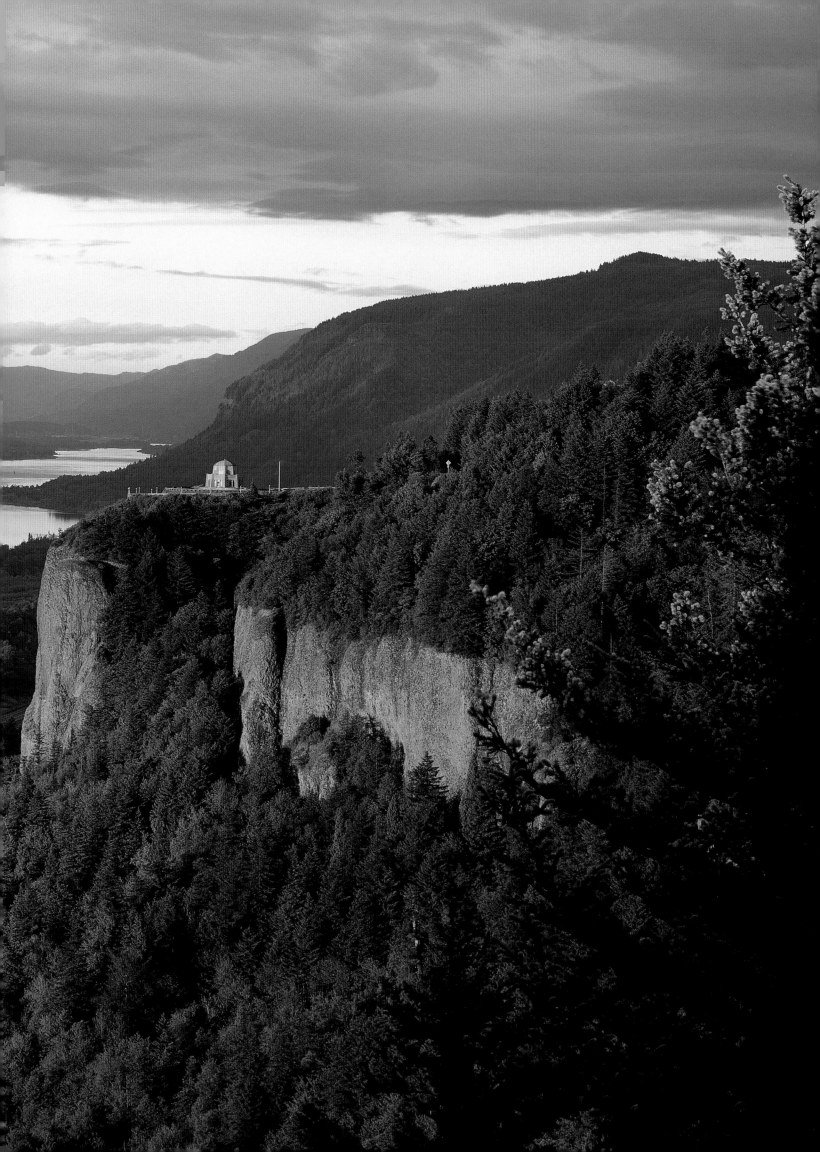

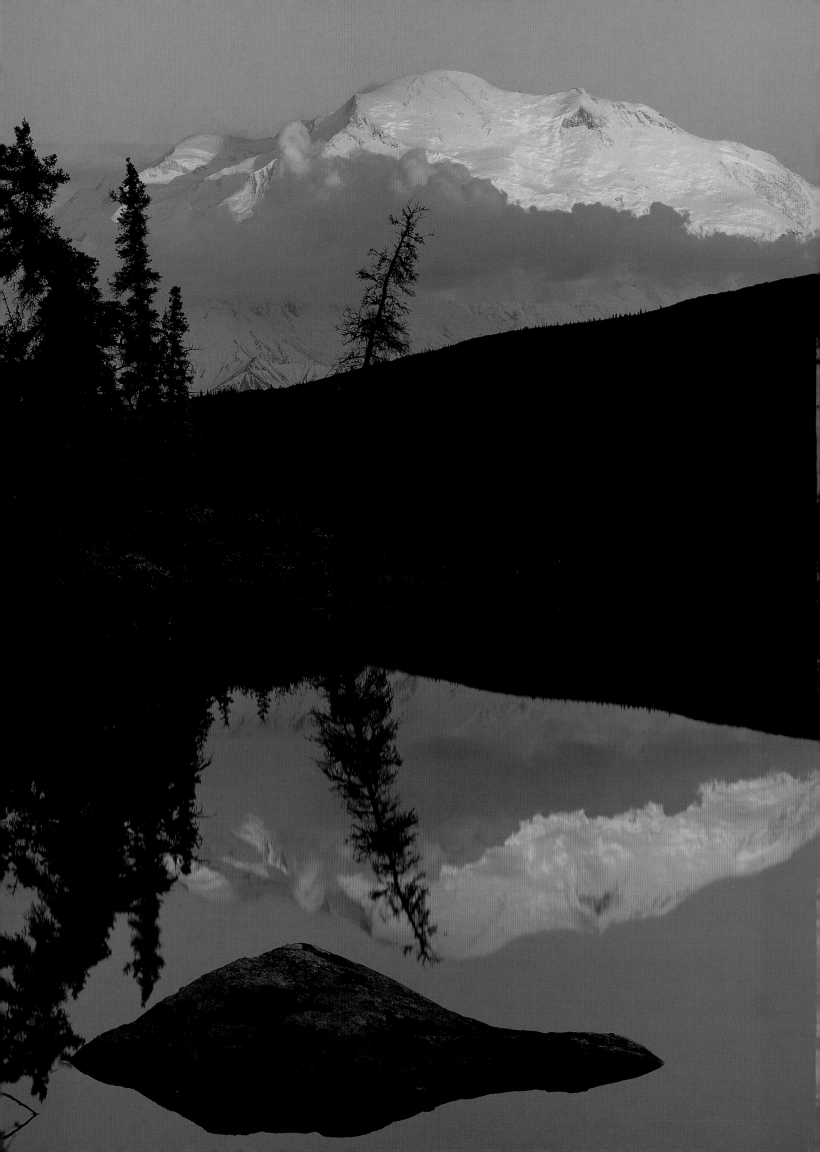

ALASKA
&
HAWAII

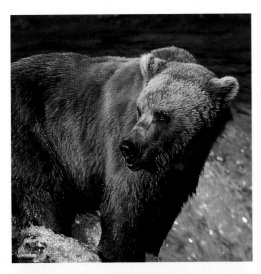

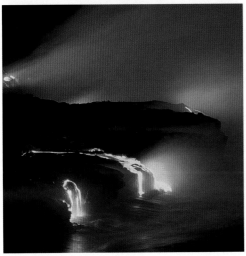

◄ *At 20,320 feet, Mount McKinley is North America's highest peak. The mountain is better described by its Athabascan name, Denali, which means "the high one."*

▲▲ *An Alaskan brown bear, also known as grizzly, fishes for salmon. A summer diet of fat-rich salmon allows the largest of bears to weigh more than one thousand pounds.*

▲ *Steam rises off lava as it spills into the cold waters of the Pacific. The Hawaiian Islands are the tips of immense, undersea mountains built up by volcanic eruptions.*

For nearly half a century, America was a neatly packaged nation of forty-eight contiguous states. Then, in 1959, the admission of two exotic, far-flung newcomers sent mapmakers scrambling. One was a massive, resource-rich chunk of northern wilderness; the other was a delicate, strategically-placed string of tropical islands. No contrast could have been more striking.

Yet the histories of these two very different states had touched once before. When Captain James Cook discovered the Hawaiian Islands in 1778, he was on his way to Alaska, in search of an eastward water route across the continent of North America. After a warm welcome by the islanders, who mistook him for their god, Lono, Cook sailed on to survey the Alaskan coast. On his return voyage, an altercation with the islanders cost him his life.

Not that history began with European discovery; Alaska's original settlers crossed a land bridge from Asia some six to perhaps fifty thousand years ago, and their descendants slowly drifted and settled over the American continents. Four ethnic groups lived peaceably in Alaska, their cultures built around its plentiful fish and game, when Vitus Bering sailed the strait that bears his name.

On the strength of Bering's 1741 expedition, Russia laid claim to Alaska in order to mine its "soft gold," the sea otter pelts so coveted back home. In 1867, when Russia offered to sell Alaska to the United States, Congress very reluctantly voted two cents an acre, while the American public jeered. Then real gold was discovered in Juneau, and what many called the "icebox" began to look like a treasure chest. Surer fortunes were made later, in salmon, copper, and oil.

Still, few have ventured north to settle. Alaska is truly our last frontier, and that is a big part of its allure. In a landmass one-fifth as large as the whole "Lower 48," our forty-ninth state boasts just half a million residents, and half of them are in Anchorage. The rest are far-flung, some beyond the reach of roads. Even Juneau, the capital, can be reached only by plane or boat.

One reward for these hardy, friendly Alaskans is to live among natural wonders fit to humble even the most seasoned traveler—soaring mountains, miles of tundra, wild animals roaming free, and night skies extravagantly colored by the Northern Lights. The scale of things is grand; Alaska claims nineteen mountains rising above fourteen thousand feet and more than half the world's glaciers.

Playing counterpoint to Alaska's rugged terrain are the softly sensual Hawaiian Islands. The tips of ancient volcanoes, they rise mid-Pacific, farther from land than anywhere else on earth. Until about 500 B.C., they were uninhabited, except by a wondrous array of birds. Adventurous sailors from the Marquises found them first; then Tahitian settlers arrived, bringing their culture with them. They were sleepy island kingdoms when Cook discovered them.

Mark Twain, who arrived by steamship in 1866, dubbed them "the loveliest fleet of Islands anchored in any sea." Even as he wrote, commerce was quickening the pace of life, and imported labor was turning the homogenous islands into a cultural melting pot. First the lure was sandalwood and whales, then sugarcane, pineapples, and shipping. Today, it is the tourist trade.

Now Honolulu is a bustling city, and Waikiki beach, once the palm-shaded playground of Hawaiian royalty, is flanked by high-rise hotels. But in this modernized paradise, it is still possible to find secluded beaches, peaceful valleys and taro fields, lush rain forests, wild orchids, even volcanoes belching fire. The sun, slipping through purple and gold into the sea, still stops tourists in their tracks. This is still the place for *aloha*—which means to face the breath of life.

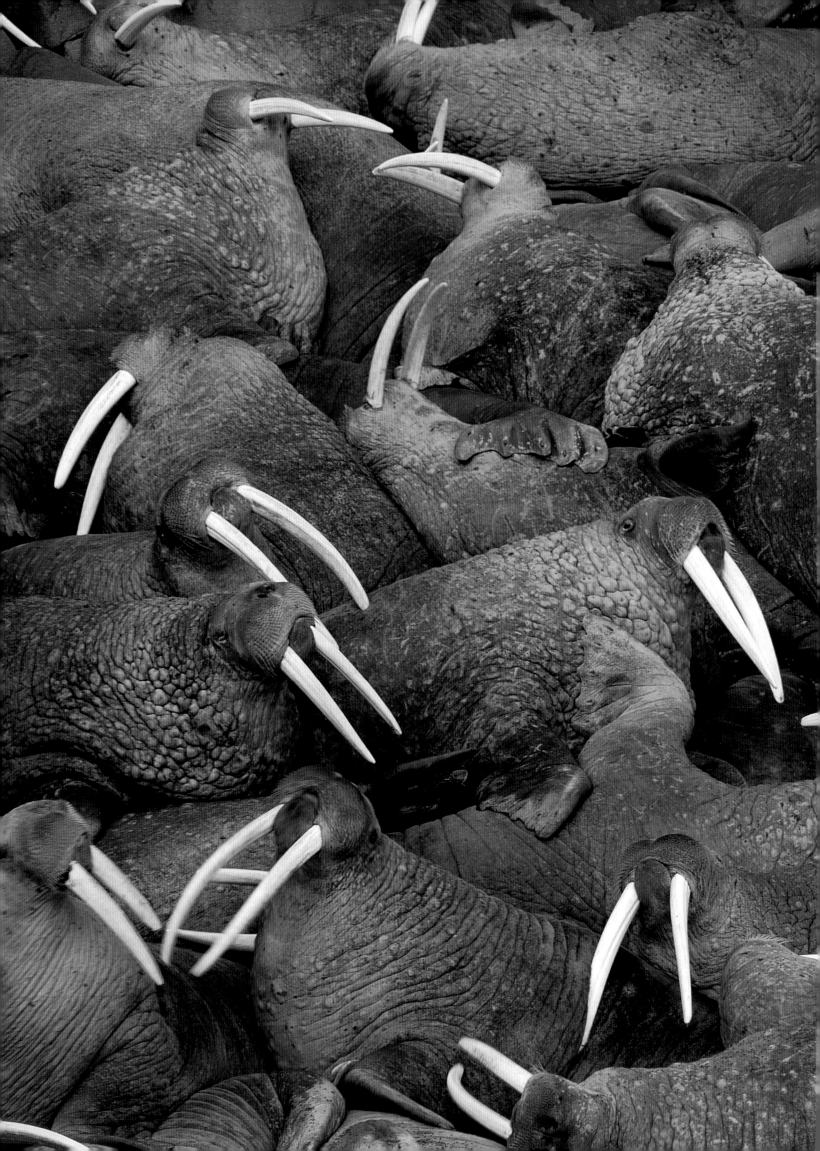

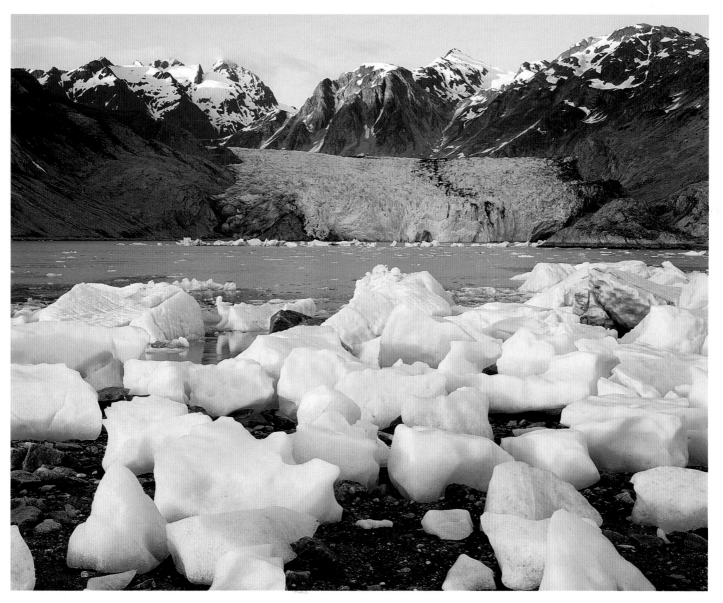

◄ Walruses rest at a "haul-out" in the Bering Sea. The genus name, *Odobenus,* means "tooth walker," referring to the way a walrus may use its tusks, as well as front and hind flippers, to move about on land. The walrus is a very social animal, living and sleeping in colonies.
▲ Ice Age remnants remain in Alaska's Glacier Bay National Park. Low tide in Muir Inlet strands icebergs calved from McBride Glacier.

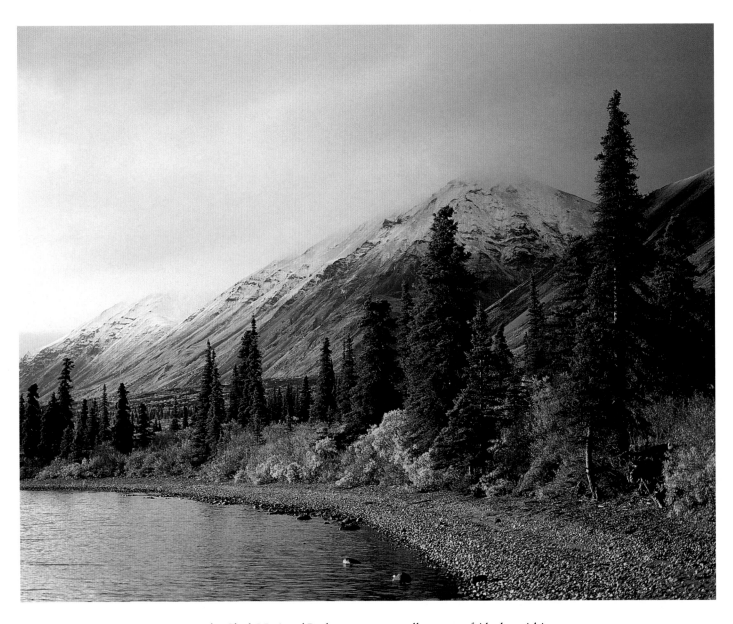

▲ Lake Clark National Park encompasses all aspects of Alaska within its borders: magnificent landscapes, glaciers, volcanoes, tundra, alpine spires, lakes, rivers, and sea coast; a variety of wildlife; and the world's largest spawning ground for sockeye salmon. Here, the wilderness shoreline of Lower Twin Lake depicts autumn brilliance.
► A bald eagle rests on a piece of driftwood along Kachemak Bay. More bald eagles live in Alaska than in all other states combined.

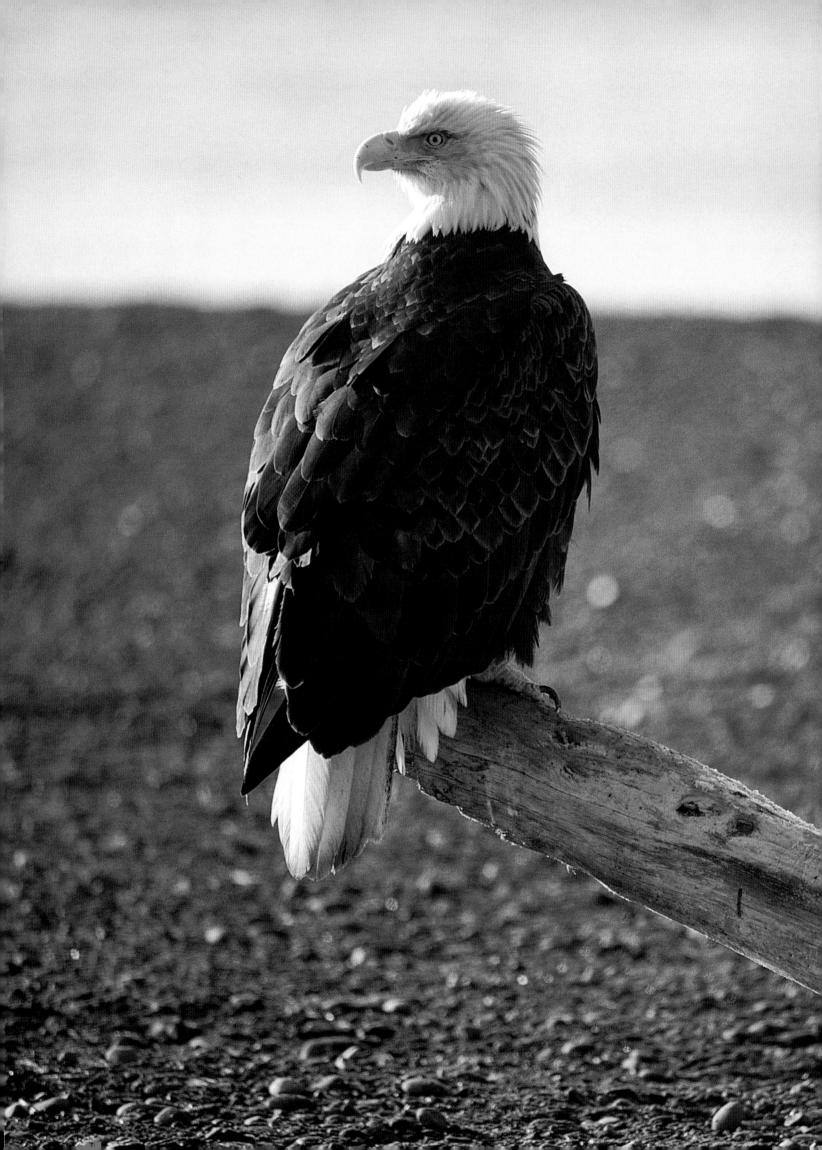

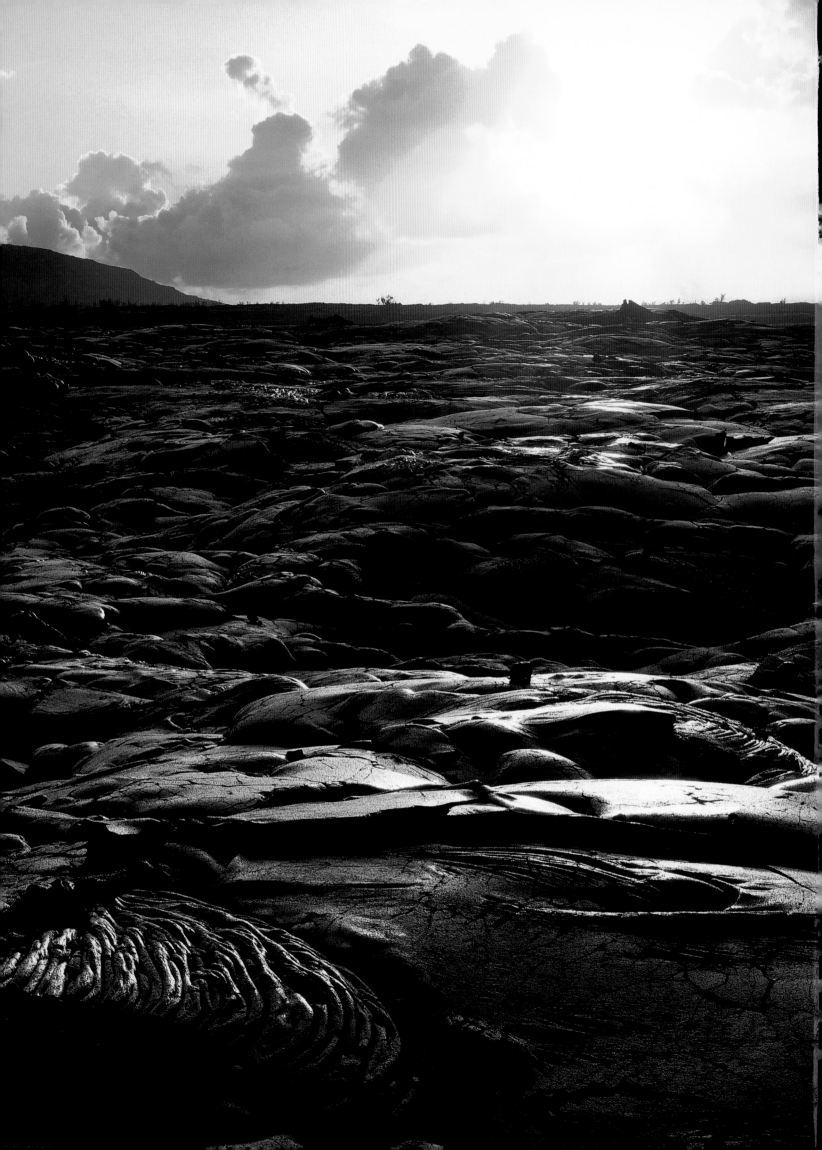

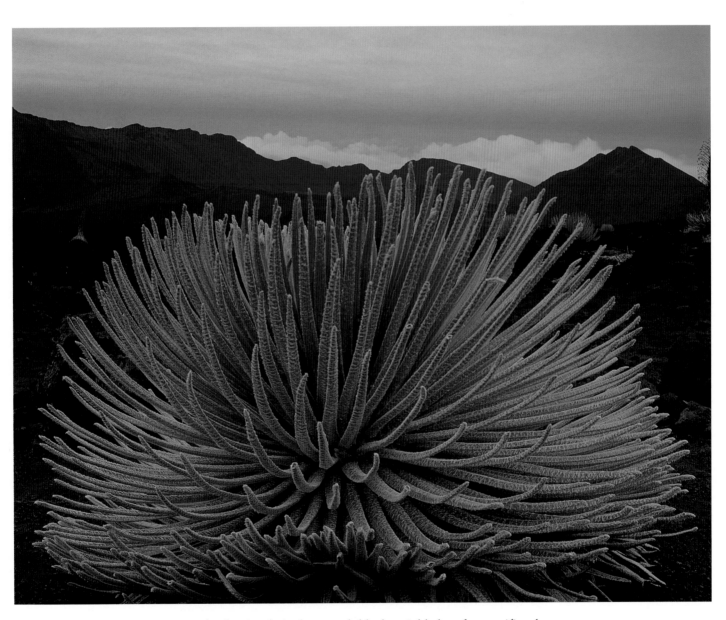

◄ Pahoehoe's relatively smooth black wrinkled surface typifies the lava flowing from Kilauea in Hawaii Volcanoes National Park.
▲ Haleakala National Park and the adjacent Nature Conservancy lands on Maui provide refuge for the endangered silversword, which grows nowhere else but on high mountains in the Hawaiian Islands. Producing a single stem of yellow and purple florets, silversword may live twenty years. It blooms only once before it dies.

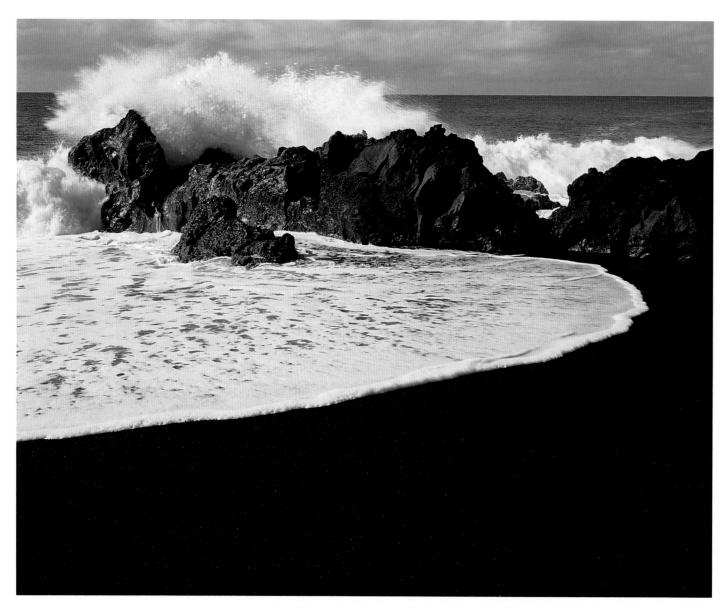

▲ Waves crash against Black Sand Beach on the Big Island of Hawaii. Mauna Loa rises some thirty thousand feet above the ocean floor.
▶ Akaka Falls plunges 420 feet. A famous site on the Big Island of Hawaii, the falls attract up to three thousand visitors per day.
▶ ▶ Morning glory and lantana paint the Puna Coast on the Big Island of Hawaii. Time and the extreme isolation of the islands were essential ingredients for development of Hawaii's unique native life.

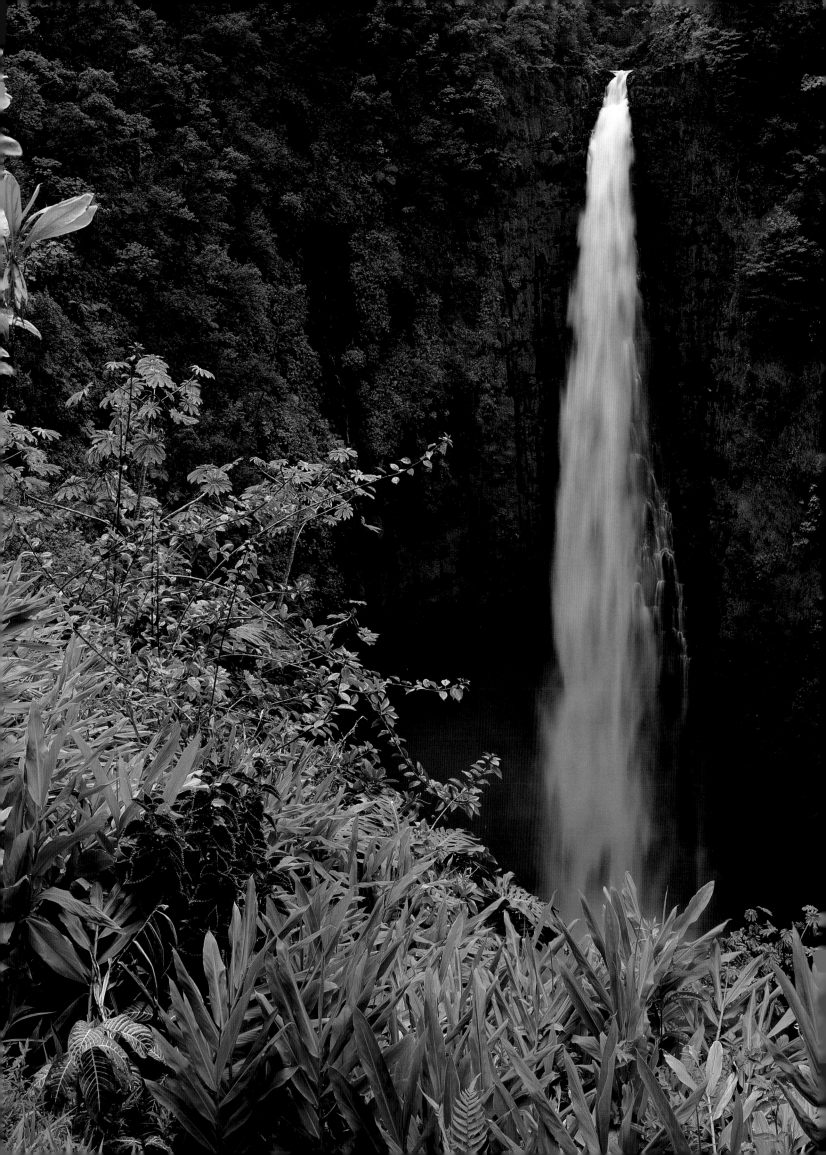

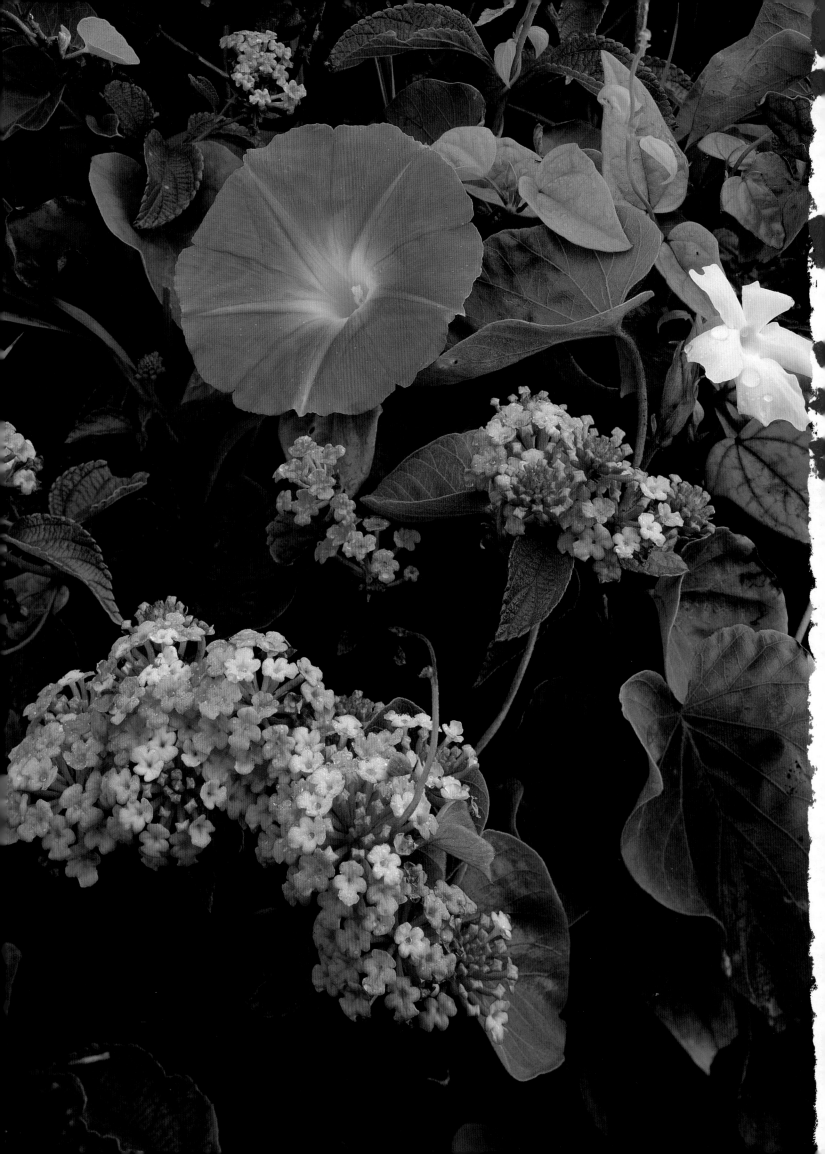